江戶圖騰

江戶圖騰 Totem In Edo
井上裕起作品集 Yuki INOUE Works

作者　　　張哲嘉
藝術家　　井上裕起Yuki INOUE
編輯出版　宇達特文創有限公司
　　　　　台北市大安區敦化南路一段312號 (02) 2700-6883
Email　　service@urdct.com
視覺設計　宇威數位設計股份有限公司 (02)2705-6308
發行　　　時報文化出版企業股份有限公司
　　　　　桃園縣龜山鄉萬壽路二段351號 (02)2306-6842

初版一刷 2018年10月
定價 新台幣1000元

ISBN 978-986-90070-4-7

目錄 Table of contents

作者序
初識到合作

「如果可以支持這樣的一個意志，

　甚至能夠發揚光大，

　應該會是我人生中的美事一樁。」

2012年初拜網路之賜，在浩瀚的資訊洪流中，發現了一位用這樣奇特的主題創作的藝術家。起初只是因為新鮮,有趣且貼近年輕世代的創作媒材，這材質稱為玻璃纖維（F.R.P.），質輕，強度是鋼材的數倍，是一種劃時代的複合媒材，近代多用於航太科技或賽車打造。

漸漸的看出他作品中的內涵與堅持，將近一年的觀察。已從純粹有趣的欣賞，轉變為認真看待他創作題材的心境，忽然想起1998年第一次在日本某畫廊真正出手，買了村上隆版畫的那種情境。也開啟了想接觸井上的契機。

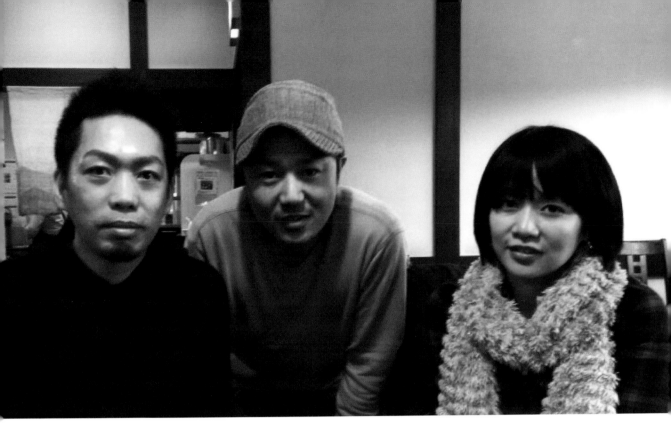

2013年春，東京新宿高島屋的金井先生為他策畫了個展，讓我有了起心動念，親眼看看他的創作。東京那年下著瑞雪，雪融的春天特別冷，那是來自亞熱帶國家的我，一週的行程中隨時遭遇著不太能理解的寒冷。

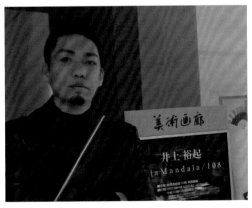

2013年4月於新宿高島屋 井上裕起個展

拜訪他位於神奈川的工作室那天，走下電車，一股刺骨的冷風吹來，大家異口同聲的叫了出聲"好冷"！出了車站，井上很體貼地開車來車站接我們。

一行人經過市區，沿途的房子越來越少，到了一塊近無人煙的空地，比鄰的是一家石材加工廠。小而輕薄的鐵皮屋工作室，讓我想起千利休的茶室，三帖、兩帖...

裡面推滿了工具、手稿與進行到一半的作品，彷彿闖進了他的大腦一般，讓我猶如發現寶庫般的欣喜。

但其中看見了一個舊式煤油立式暖爐，上面放著一個斑駁的茶壺，印象中我只有在昭和年代電影中才會看到的物品。

「很冷吧？」我用著簡單的日文這樣的問他，他用靦腆的微笑尷尬的回我說：「這些年已經習慣了」。

但是我知道單薄的鐵皮屋與小暖爐是無法提供他每日十個小時的溫暖的，清晰的理念與堅強的意志力才是支持他能夠持續的待在這裡的原因。

當下內心中已經出現一個聲音，如果可以支持這樣的一個意志，甚至能夠發揚光大，應該會是我人生中的美事一樁。

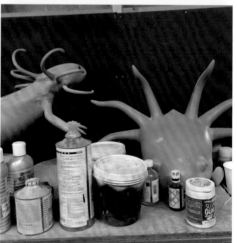

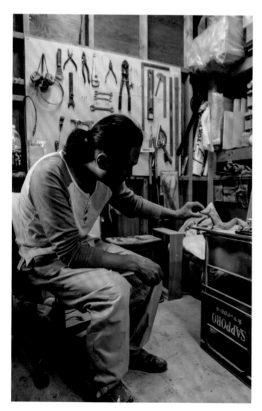

井上裕起工作狀況

工作室角落

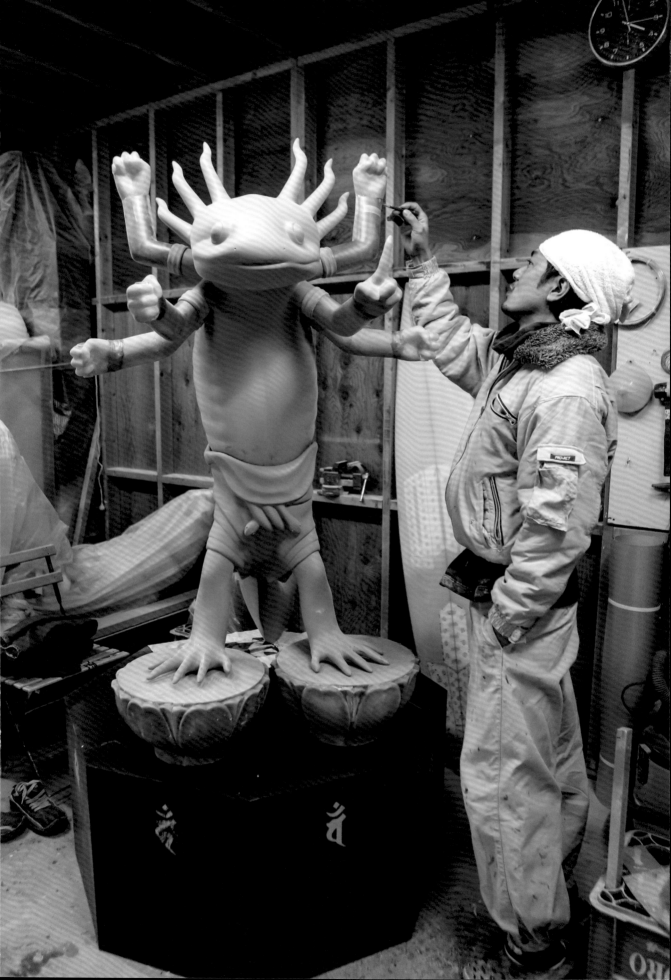

Author's preface

From first met to collaboration

" If I can support such a determination ,

can even carry forward,

it should be one of wonderful things in my life. "

In the early 2012, thanks to the Internet, I found an artist who created this strange theme in the vast information flow. At first that's just because the artwork looks fresh, interesting and closes to the creation media of the younger generation. This material is called glass fiber (F.R.P.).
It is light , and several times stronger than steel. It is an epoch-making composite medium. It is mostly used in aerospace technology or racing cars.

Gradually I saw the connotation and persistence in his works, which was observed for nearly one year. It has changed from a purely interesting appreciation to a serious consideration of his creative theme.At that moment, I remembered in 1998, for the first time I really wanted to collect and bought Murakami's artworks in a Japanese gallery.
I also consider about touching INOUE.

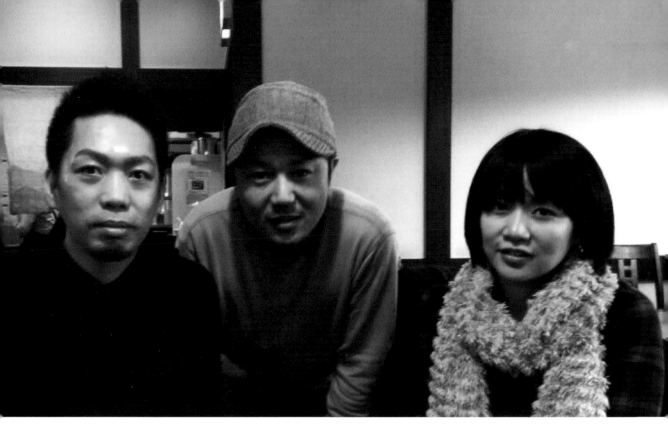

In the spring of 2013, Mr.Kanai from Shinjuku Takashimaya had him a solo exhibition, which let me want to see his creation.
In the year, it was under the snow in Tokyo, and the snowmelt spring was particularly cold. It was from the subtropical country, I felt the cold that I could not understand any time during the week.

Visiting his studio in Kanagawa, then got off the tram, a bitter cold wind blew, and everyone called out "so cold"! Out of the station, Inoue considerate drove to the station to pick us up.
As we pass through the city, there are fewer and fewer houses along the way.
Finally, we arrived at an unmanned open groumd, next to a stone processing factory.
The small and light metal house studio reminds me of Sen no Rikyū's tea room, three posts, two posts...

It was filled with tools, manuscripts, and works that were halfway through, as if it had broken into his brain, making me feel like a treasure house. But I saw an old kerosene vertical heater, there is a mottled teapot on it. The items I only saw in the movies of the Showa era.

[Is it cold?] I asked him in simple Japanese. He replied with a shy smile to me: [These years have become accustomed].

But I know that a thin metal house and a small heater can't provide him with ten hours of warmth a day. A clear target and strong willpower are the reasons why he can continue to stay here.

There is already a voice in the heart then, If I can support such a determination , can even carry forward, it should be one of wonderful things in my life.

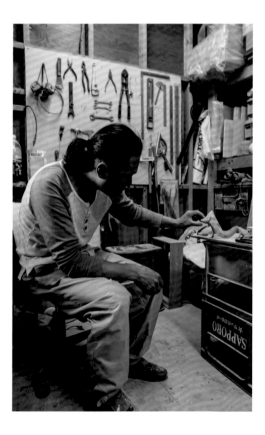

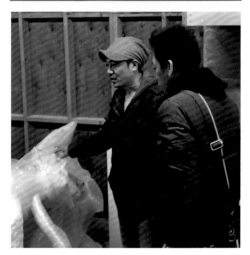

天明屋 尚
推薦序

井上裕起は現在、多摩美術大学美術学部彫刻科の非常勤講師をする傍ら、勢力的に作品制作を行っている。

制作当初は石材を用いて作品を制作してきたが、近年は化学的な素材へと移行し、より自由度を増してきている。

両生類として住み慣れた水から陸にあがるとき、決死の覚悟で移行する生来の変容者・サラマンダー。

井上が一貫してモチーフとして扱ってきたこのサラマンダーは即ち「進化」の化身であり、権化である。

彼はこの異生物の視点を借りることにより、世界の様々な事象や歴史・文化を10年以上にわたって一貫して切り取り続けてきた。それは作家の分身、内面の反映であると同時に、流転する時代精神の体現者として、時にユーモラスに時にシニカルに、様々な形態へと変容する。また、時にはそこに歌舞伎役者や花魁、刺青を入れた侠客などの姿を借りて、日本という国に連綿と受け継がれてきた粋で豪快な美意識すらも体言してきた。

井上とは2010年8月にスパイラルガーデンで開催された、私のキュレーションによるBASARA展に大作「OIRAN」を出展頂いてからの付き合いである。

BASARAとは、室町時代の婆娑羅大名や戦国末期のかぶき者、幕末の絵師などの気風に通じる華美で型破りな美意識を指す。

サラマンダーという奇異なモチーフで、変幻自在に世俗を斬り裂く井上の作風は、まさにこのBASARAと呼ぶにふさわしい。

インターネット・テクノロジーが世界を覆い、否応なしの変革を余儀なくされる近年。

変わらぬことは美徳なのか、変化は悪か?

人間世界の理を超越した異形はこれからも超然と問いかけることだろう。時代状況とともに流転し続ける井上作品は、変化の著しい昨今、ますます重要性を増してきていると言えよう。今後も、井上作品がどう進化し変容して行くのか注目して行きたい。

現代美術家　天明屋 尚

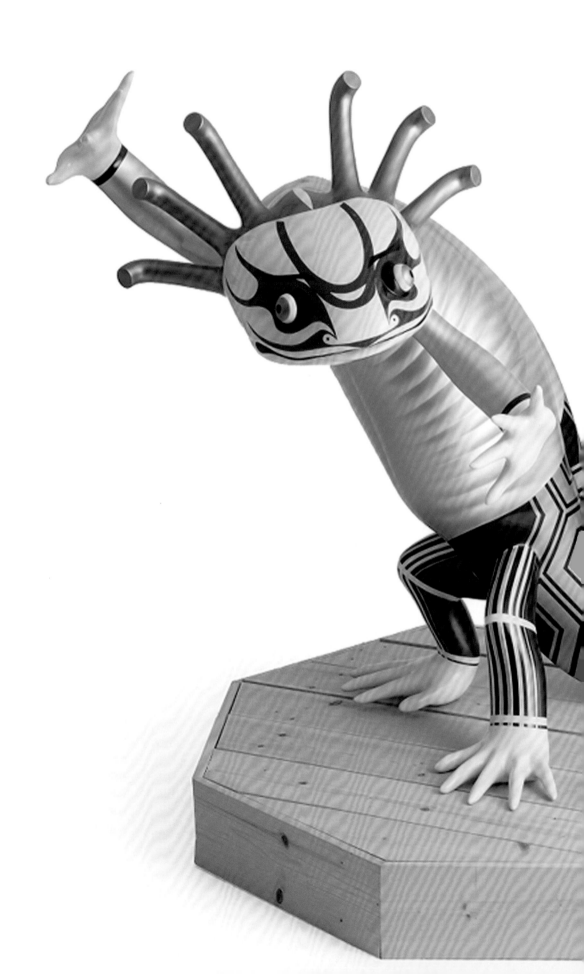

Tenmyouya Naoshi
Recommend Foreword

Inoue Yuuki is now actively producing works. At the beginning of the work he has produced works using stone, but in recent years he has shifted to chemical materials and are getting more freedom. Salamander, the innate transformational organism which shifts with ambivalent death when going to land from the familiar water as an amphibian.
This salamander that Inoue consistently treated as a motif is an incarnation of "evolution", it is authorization.

By borrowing the viewpoint of this heterogeneity, he has consistently cut out various events, history and culture of the world for more than 10 years. It is a reflection of the writers' alter ego, inside, and at the same time transforms into a variety of forms, sometimes humorously, sometimes cynically, as an embody of the spiritual period spirit. In addition, sometimes borrowed the appearances of Kabuki actors, flower

sculptures, tattoos and other people there and even inscribed even the stylish and dazzling aesthetic sense that has been handed down to the country of Japan.

Inoue is a relationship after having exhibited the masterpiece "OIRAN" at the BASARA exhibition by my curation which was held in the spiral garden in August 2010. BASARA refers to beautiful and unconventional aesthetic sense that leads to the style of Mamochon era Ayakohora Daimyo and the last days of the Sengoku period, the painters of the end of the Tokugawa period. With a strange motif called Salamander, the style of Inoue who splits the secular freedom freely and freely is suitable for calling this BASARA exactly.

In recent years, Internet technology covers the world, forced to reform inevitably.
Is not the change unchanged virtue, the change is evil? The irregular shape which transcends the theory of the human world will still be questioned in the future. The Inoue's works which continues to flow with the times of the times is increasingly becoming more and more important in recent times with a remarkable change. I would like to keep an eye on how Inoue's work evolves and changes.

Modern artist Tenmyouya Naoshi

井上 裕起
作品的特色和分類

石雕時期

這是井上裕起從歐洲研習回日本後的一個階段，我稱為"石雕時期"，在石材的選擇上也接近義大利公共建築的雕塑影響，而選擇了大理石。大家會看到的作品不管在風格與調性上，都是比較擬真的，唯一特別之處就是頭上的六隻角，會比真實生物來的短，是因為受限於材料特性，無法雕出如此纖細比例的角。因為這材質的受限，雖然開始了他自己在創作材質上的重新思考，但也變成他早期創作的特色。

Salamander是井上在各系列創作中很主要的一個特色，中文稱為蠑螈或是六角恐龍，幾億年來都沒有再演化，是一種活化石。
他以這活化石隱晦的在表示自己國家文化的底蘊，在雕塑上再加入本國文化風格或是本國流行文化元素，乃至於生活中感動的印象。所以我們在他的作品上，大致看到三大區塊的分野。

像是早期的石雕創作，雖然作品不多，卻是開啟他重新創作與自我定調的基石。其次是日本傳統浮世繪與其文化的圖像投射在他的作品上，尤其是江戶時期的影響非常深遠。而另一是井上成長過程中的印象，或是生活中延伸的投射。

傳統浮世繪與其文化

對於一個出生在1970年代的我來說，浮世繪的印象大多是在家中父親掛在玄關，那平面且不知名的畫，以及港口委託行櫥窗那些日本舶來品的包裝與圖像。
直到在軍中服役時，看了一本關於梵谷的書，才驚覺原來浮世繪是影響歐洲印象派許多大師創作的核心。

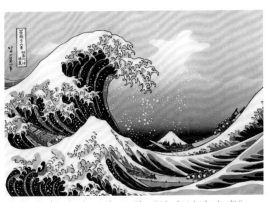

葛飾北齋 富嶽三十六景《神奈川沖浪裏》
圖片出處：網路

去除景深3D的觀念，粗曠的線條與色塊所構築的畫面，完全顛覆歐洲文藝復興時期的畫作概念，沒人想到一開始的媒介會是因為19世紀中的日本茶葉與陶器包裝紙。

浮世繪幾乎描繪了江戶時期的文化、生活、以及內心不可道人的渴望，美人畫、役者繪、名所繪、武者繪、相撲繪、戲畫、鳥羽繪、長崎繪橫濱繪、春畫等……生活延伸的投射，期間也有許多廣為人知的大師，葛飾北齋、歌川廣重、喜多川歌麿、歌川國芳等，讓我們可以一窺那個時期。

上述這一類題材的作品，比例上相對的高，卻也成為井上創作上主要的標誌。

而這系列眾多作品中，對於台灣的藏家意義最特別的，只有2014年創作的butterfly [WREATH] Black、Red、White 這三件作品莫屬。

WREATH 這系列作品的原意，是在於日本人聖誕節與正月都會在家們口掛著圓圈型的裝飾，為的是祝福到訪的友人，或驅除不好的運氣。這三件作品正巧是他第一次到台灣個展，感念日本311地震時，台灣民間為友邦日本積極的捐款。

所以特別將上面的櫻花換成我們的國花"梅花"，浮現在日本傳統祝福的底紋上。

可謂稀有度非常高的作品。

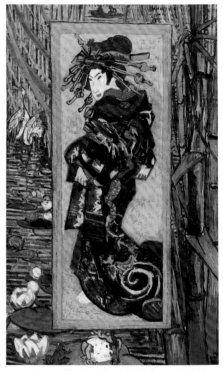

Van Gogh梵谷 《日本情趣：花魁》
圖片出處：網路

井上裕起還有另一能見度很高的系列作品，"和雕"刺青(IREZUMI)在他作品上出現，這多少也受了他的好友"天明屋 尚"這位藝術家的影響，有著密不可分的關係。提起天明屋 尚這位藝術家，他在近幾年日本的刺青藝術中有著很重要的地位，作品風格上非常擅長日本極道風格的表現，早期作品時常在日本重要的刺青雜誌中發表。

日本的"和雕"刺青(IREZUMI)大約在江戶時期，開始有系統的出現，最開始採用的是消防人員。

因為江戶城街道細密的市町規劃，也導致當時消防員有著非常細密且有系統的責任區域劃分，為了讓殉職的消防隊員能夠辨識，當時並無DNA辨識乃至於齒模辨識系統，所以在身上刺青就成為那個時代唯一的方法。

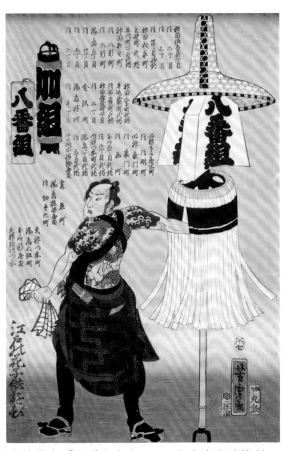

歌川芳虎「八番組加組」，當時消防隊編制
圖片出處：網路

井上裕起 2014 butterfly [WREATH]
Black、Red、White

IREZUMI系列作品中,最常見的尺寸約莫為28公分左右的高度,有的作品在創作時會連底座一併完成,也有少數藏家另外再追加的。小的尺寸有到15公分高,大的有到90公分高,其中各個型態神情各有不同,十分傳神。

短手、短腿、著重表情與尾巴波浪般的弧度,是井上裕起認為Salamander再塑形時,最完美的比例。

其中我個人認為比例最完美的的作品,應該是2012年完成的那件90公分高的IREZUMI,這件作品剛好符合井上所述的完美條件,尤其表情非常的可愛生動。

所以在Uspace畫廊的工作人員給這件作品取了"發仔"的綽號。

另外一件我覺得非常特殊的Salamander IREZUMI,就是2015年底的一件IREZUMI。若要說是如何的特殊,其特殊性在於他首次融合了台灣廟宇文化圖騰,在他的創作中。

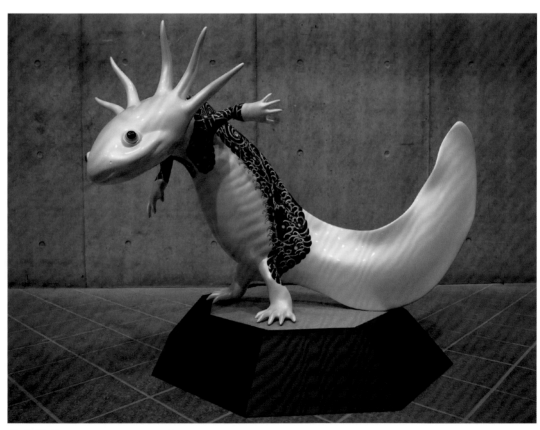

井上裕起 2012 Salamander [IREZUMI]

其中的故事開始於2015年9月，因為台南的一位藏家收藏了一件超大作品，而作品那間和室需要安裝擺置，所以我與藝術家開始了三天的台南之旅。

下榻的旅館鄰近關帝廟，一天上午我們就去了關帝廟參拜，在我的導覽下，那是他第一次那麼仔細的看台灣的廟宇，正因為井上最開始的創作是石雕，自然而然對於廟宇的龍柱產生極高的興趣，也極為讚嘆其雕工的生動與魄力。

那件2015年的Salamander IREZUMI也就因為這樣的影響而產生，而在2015年12月的Uspace藝廊個展中，出現了這件作品。

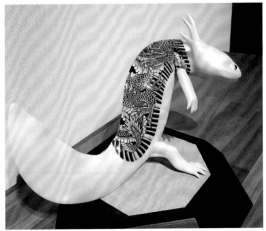

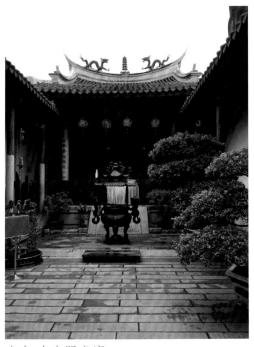

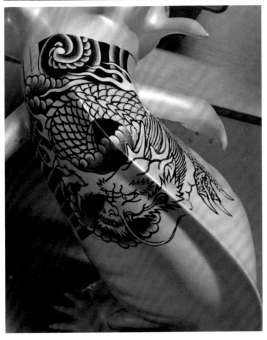

左上 台南關帝廟
右上 抽到吉籤果然工作順利
右中/右下 靈感來自台南關帝廟龍柱的創作

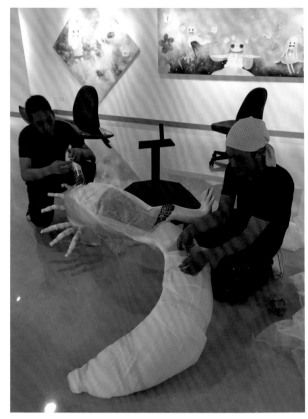

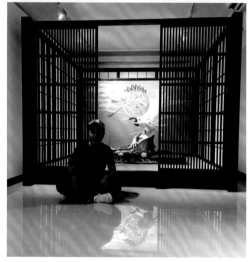

左上/右　於藏家家中裝置花絮
左下/完成

生活中延伸的投射

大部分台灣讀者應該是對於鹹蛋超人(Ultraman)那件作品印象較為深刻，因為某受歡迎的網路平台曾經報導過這件作品，而讓井上開始受到台灣及華人語系的地區的關注。

日本的卡漫文化影響了全球青少年的成長認知，也因此許多在影片中所出現的日本傳統文化，也在潛移默化的過程中自然地被吸收。更不用說日本創新的英雄形象，甚至是反派角色都會成為他們成長過程中奇幻的回憶。

鹹蛋超人（ウルトラシリーズ，Ultraman Series）salamander[Ultraman] 2014與哥吉拉(ゴジラ) salamander [NO NUKES] 2013年等系列作品是圓谷製作公司(株式會社円谷プロダクション)所認可創作的少數藝術創作，所以在意義上算是非常珍貴的。

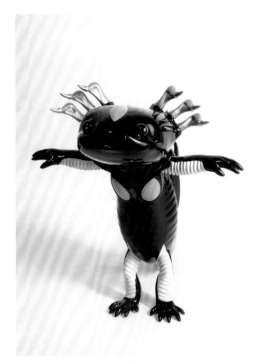
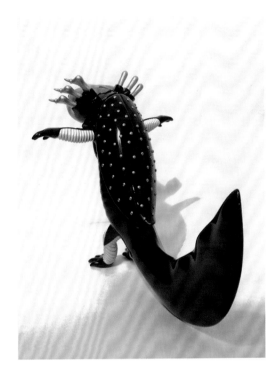

salamander [Z-TON]

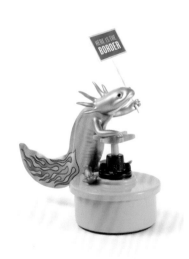
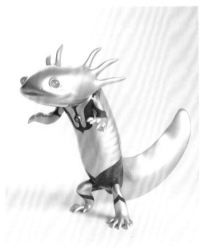
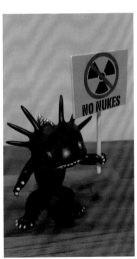

左 salamander [BORDER]
中 salamander [HERO]
右 salamander [NO NUKES]

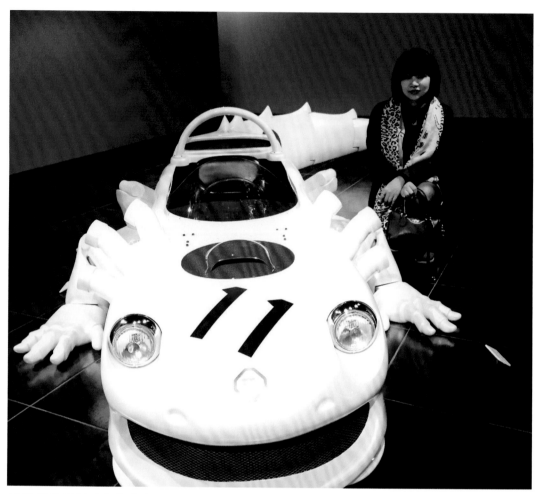

新宿高島屋[F1]首度展出

說起圓谷製作這一個公司本人是非常敬重的，創始人圓谷英二先生能夠在非常貧脊的環境中，創造出許多擬真的特效，進而想像出許多想上述的科幻角色，專注、不妥協，這是我看到圓谷先生的精神，這也是年少時期喜愛製作模型的我所崇拜的一個原因。

近兩年比較指標的作品，即大型作品 salamander〔F 1〕2016年。

這是本田車隊在1965年第一次在墨西哥站F1奪冠的日本車(代號RA272)，所以看到在作品上塗裝11號編號，是非常有特殊意義的，

至於車頭的線條有點保時捷996的線條與車燈，應該是在一次台灣展覽時開我的車載他，而激發他在創作上所修正的。

因為這個主題的創作概念，在"鯢百態"畫作中"一級方程式之圖"2015年完成的，當時在車頭的表現上還是比較想要接近本田廠車，像是進氣口的表現與無車燈。

然而，這件作品也像是本田賽車當時在F1一樣，得到岡本太郎當代美術館第20屆岡本太郎現代藝術賞2017年的優勝。

版數的雕塑作品JET系列 Limited Edition-
J.E.T series 我們在2015年初開始與井上討
論新的計畫，嘗試用當時台灣很流行的3D技
術創造出版數的雕術品，我們稱為
"JET" (Japan Evolution Taiwan)日本與台
灣的進化。

以該作品做為每年唯一一檔個展中，由台灣
獨家發表的作品，剛開始規劃版數為60版，
30件在台灣，另外30件則在日本合作的畫
廊銷售。

井上他先以玻璃纖維材質雕塑出一件26公分
高的素面原型，我再以3D掃描的技術將作品
數位化，然後用軟體再修正3D技術列印後的
誤差，像是鼻孔、肋骨與眼睛周圍都是需要
強化的部分。期間我也列印出幾件原型，手
工打磨然後上噴漆，調整了許多次。

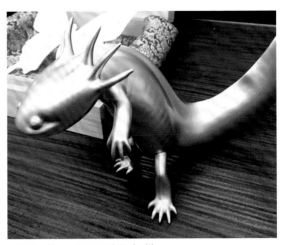

J.E.T. 第一隻3D列印打樣

在研發過程中也跑了許多次的工廠，當時台
灣並沒有專門以塑料製作藝術品的廠商，在
溝通過程中十分辛苦;甚至後續要如何與日本
廠商合作，難度頗高。

過程中幾家廠商無法達到標準而毀約，以上
的事情曾經讓我一度想放棄，但是覺得有機
會藉此而提升台灣工廠生產的產品附加價值，
那是一舉兩得，索性就硬著頭皮做了。

好事多磨，經過研發生產的波折後，終究完
成了這一個艱難的任務。後續的市場消息也
讓大家十分振奮。

原先台灣20件採預購制，預購價格略低於正
常銷售價格。原型打樣照片一曝光，沒想到
預購的人潮就爆滿，甚至願意用原價訂購，
畫廊還緊急向日本的配額調貨，這結果讓我
們非常振奮。

繼2015年JET Silver後2016年也推出
JET Gold在台灣掀起了一陣旋風，甚至牽動
了港台的藝術公仔(Art Toy)收藏市場，開始
讓這市場族群提升收藏能量進入到真正的藝
術品收藏領域。這是當初我們始料未及的。

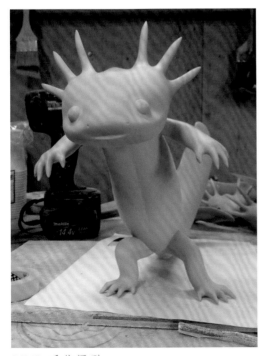

J.E.T. 手作原型

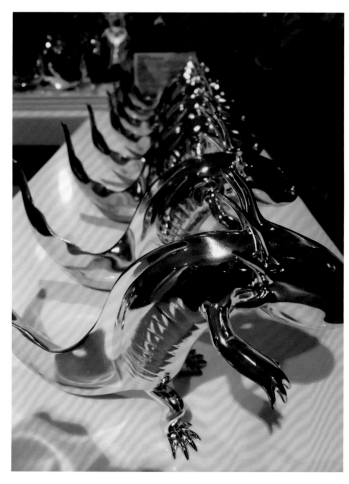

J.E.T. 2015
J.E.T.GOLDEN 2016

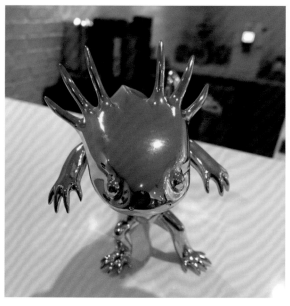

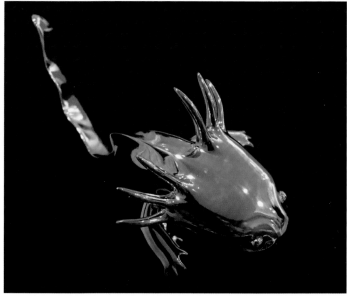

The Features and Classification of Inoue's works

Salamander is a major feature of Inoue's various series creations. It is called a 蠑螈 or a 六角恐龍 in Chinese.
It has not evolved for hundreds of millions of years, and is a living fossil.
He used this fossil stone to conceal the essence of his country's culture, and added his own cultural style or national pop culture elements to the sculpture, and even the impression in life. So we saw about the division of the three major blocks in his works.

Like the early stone carvings, although there are not many works, it is the cornerstone for his re-creation and self-regulation.
Secondly, the images of traditional Japanese ukiyo-e and its culture are projected on his works, especially the influence of the Edo period.The other is the impression of the growth , or the projection of the extension in life.

Stone carving period

This is a stage after Inoue's study from Europe to Japan. I call it the "stone carving period". In the choice of stone is also close to the sculpture effect of the public buildings in Italy, and the choice of marble. The works that everyone will see are more realistic in style and tonality. The only special thing is that the six corners on the head are shorter than the real creatures because of the limited nature of the material and the inability to sculpt such slender proportions. Because of the limited nature of this material, he began to rethink his own creation material, but it also became a feature of his early creations.

Traditional ukiyo-e and its culture

For me born in the 1970s, most of the impressions of ukiyo-e are the planes and unknown paintings that my father hangs on the porch at home, and the packaging and images of Japanese imported goods in the port.
It was not until the military service that I read a book about Van Gogh, and then realized that ukiyo-e was the core of many masters of European Impressionism. The concept of three-dimensional depth of field is removed, and the images of such rough lines and color blocks completely subvert the concept of paintings in the European Renaissance.

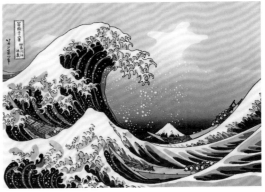

Kanagawa Oki Nami Ura
《The Great Wave off Kanagawa》
by internet information

No one thought of the beginning of media of communication is because of Japanese tea and pottery wrapping paper in the 19th century.

Ukiyo-e depicts almost the culture, life, and inner desires of the Edo period. Beauty paintings, servants paintings, famous place paintings, military paintings, sumo paintings, opera paintings, bird feather paintings, Nagasaki paintings, Yokohama paintings, pornography paintings, etc. are mostly projections of life extensions.

During the period, there were also many well-known masters, such as Katsushika Hokusai, Gegawa Gyeon, Kitakawa Kawasaki, and Gechuan Guofang, so that we can have a glimpse of that period.

The above-mentioned works of this kind are relatively high in proportion, but they have also become the main symbol of Inoue's creation. Among the many works in this series, the most special meaning for Taiwan's collectors is the three works of butterfly [WREATH] Black, Red and White created in 2014.

The original intention of WREATH's series is that the Japanese Christmas and the first month will have a circle-shaped decoration at home, in order to bless the visiting friends or to drive away bad luck.

These three works happened to be his first solo exhibition in Taiwan. When he felt the 311 earthquake in Japan, the Taiwanese people made positive contributions to Japan. Therefore, in particular, the cherry blossoms above were replaced with our national flower "Plum Blossoms", which appeared on the shading of Japanese traditional blessings. It is a very rare work.

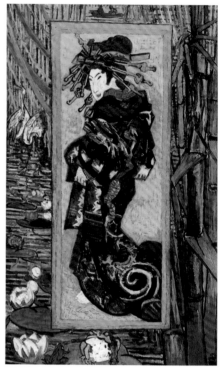

Van Gogh
《The Courtesan (after Eisen)》
by internet information

Inoue Yuka has another series of highly visible works. The tattoo (IREZUMI) appears on his work, which is somewhat influenced by the artist of his friend " Hisashi Tenmyouya". Mentioning the artist - Hisashi Tenmyouya, he has a very important position in the tattoo art of Japan in recent years. His artwork is very good at the performance of Japanese gangster style.

Early works are often published in important Japanese tattoo magazines.

Japan's " IREZUMI " tattoo began to appear systematically around the Edo period ,the first use was firefighters. Because of the careful city and town planning of Edo Castle, the firefighters at that time also had a very detailed and systematic division of responsibility. In order to allow the demobilized firefighters to be identified, there was no DNA identification or even a tooth model identification system at the time, so tattooing on the body became the only method of that era.

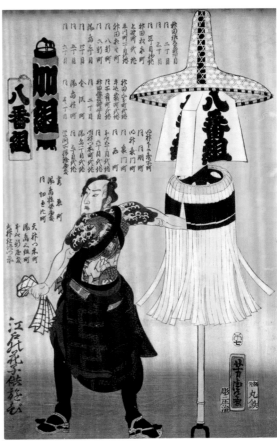

Utagawa Yoshitora 《八番組加組》, Fire fighter by internet information

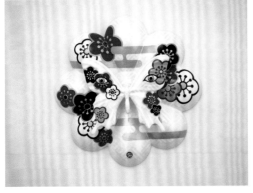

井上裕起 2014 butterfly [WREATH]
Black、Red、White

In the IREZUMI series, the most common size is about 28 cm, some works will be completed with the base at the time of creation, and a few other collectors will add it. The small size is 15 cm high, and the large one is 90 cm high. Each type of look is different and very expressive. Short hands, short legs, emphasizing expressions and the undulating arc of the tail are the perfect proportions when Yuki Inoue thinks that Salamander is reshaped.

Among them, I personally think that the most perfect work should be the 90 cm high IREZUMI completed in 2012. This piece fits with the perfect conditions described by INOUE, especially the expression is very cute and vivid. So the staff at Uspace Gallery gave the piece the nickname - "Fa Zai".

Another Salamander IREZUMI that I also think very special is IREZUMI in the end of 2015. To say how special it is, its particularity is that he first merged the totem of Taiwanese temple culture in his creation.

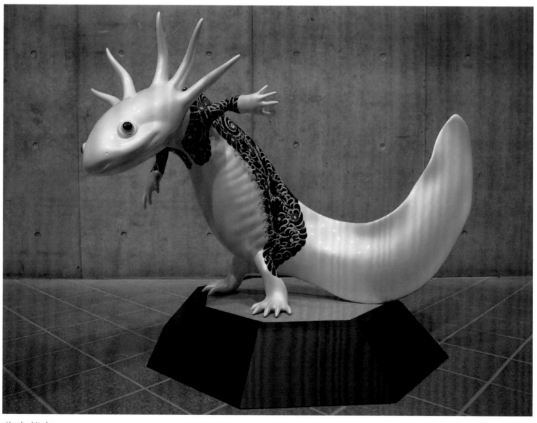

井上裕起 2012 Salamander [IREZUMI]

Because a collector in Tainan collected a
huge artwork which needs to be installed,
then I had a three-day trip to Tainan with
the artist. The hotel is close to the Guandi
Temple.

One morning we went to the Guandi Temple
to pray. Under my guide, it was his first time
to look at the temples in Taiwan so carefully.
It was because his first creation was a stone
sculpture. Naturally, he was extremely
interested in the dragon pillars of the temple
and he was very impressed by the vividness
of the carving.

The 2015 Salamander IREZUMI was born out
of this influence, and appeared in Uspace
Gallery solo exhibition in December of 2015.

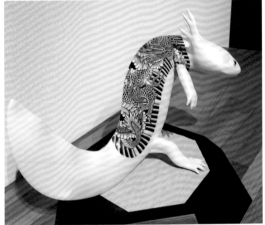

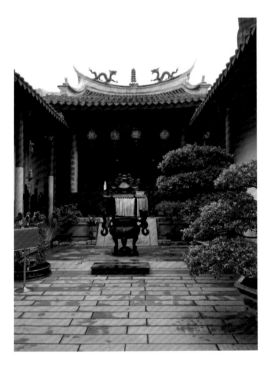

Tainan temple《Guandi Temple 》
This creation is inspired by the Dragon pillar
of the temple

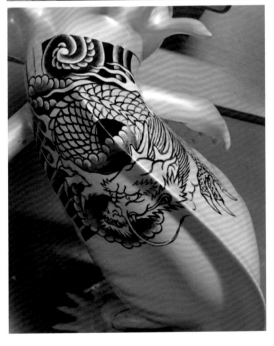

29

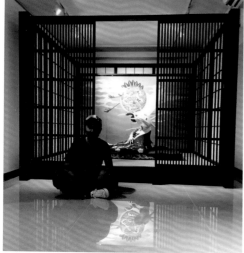

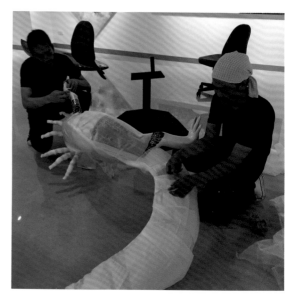

Installing in the collector's home

Extended projection in life

Most Taiwanese readers should be more impressed with the work of Ultraman, which was reported on a popular online media. Let the artist begin to be paid attention by Taiwan and Chinese language regions. Japan's cartoon culture has influenced the growth of young people around the world, and as a result, many of the traditional Japanese cultures that appear in the film are naturally absorbed in the process of subtle influence. Not to mention the heroic image of Japan's innovation, even the villain, will become a fantasy in their growth. "Ultraman Series" salamander [Ultraman] 2014 and Gogurah (ゴジラ) salamander [NO NUKES] 2013 and other series of works are a few of the artistic creations recognized by Tsuburaya Productions Co., Ltd (Shibuya). So it is very precious in the sense.

Speaking of the company, I am very respectful. The founder, Mr. Tsuburaya Eiji, can create many imaginary special effects in a very poor environment, and imagine many of the sci-fi characters, focus on and not compromise. This is the reason why I admire. The work of comparing indicators in the past two years, namely this large-scale work salamander [F1] 2016. This is the first Japanese car that the Honda team won in Mexico in F1 in 1965 (code RA272). So it's very special to see the number 11 on the painting. As for the line of the front of the car, the line and the lights of the Porsche 996, it should be that I drove him in a Taiwan exhibition and inspired him to make corrections in his creation. Because the concept of creation of this theme was completed in 2015 in the painting of the 鯢百態, the performance of the front of the car was relatively close to the Honda factory, such as the performance of the air intake and headlights. However, this work is also like the Honda racing car at the time of F1, and won the 20th Taro Okamoto Modern Art Award in Taro Otamoto Museum of Art in 2017.

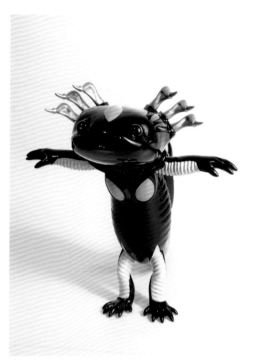
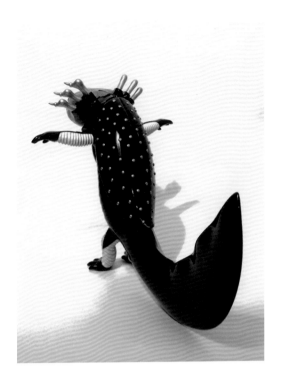

salamander [Z-TON]

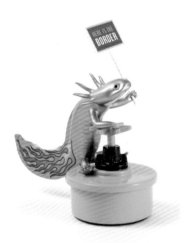
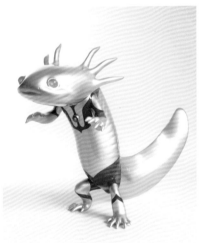
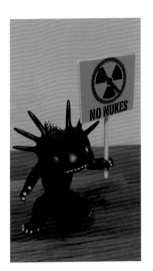

左 salamander [BORDER]
中 salamander [HERO]
右 salamander [NO NUKES]

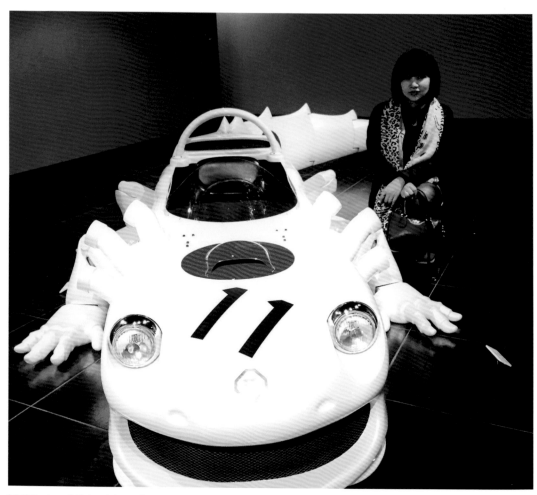

[F1]first exhibited in Takashimaya Shinjuku

We started discussing new projects with Inoue in early 2015, trying to create a number of sculptures using the popular 3D technology in Taiwan at that time.
We call it "J.E.T" (Japan.Evolution.Taiwan) evolution of Japan and Taiwan.
With this work as the only one solo exhibition in the year, the works exclusively published by Taiwan have just started to be 60 pieces, 30 pieces in Taiwan, and 30pieces in other Japanese galleries.
Inoue first sculpted a 26 cm high plain prototype with fiberglass material. Then I digitized the work with 3D scanning technology, Then use the software to correct the error after printing by 3D technology, such as the nostrils, ribs and around the eyes

are the parts that need to be strengthened. During the period, I also printed a few prototypes, hand-polished and then painted, adjusted many times.
In the process of research and development, I also visited many factories.
At that time, Taiwan did not have a manufacturer specializing in plastics .
It was very hard in the process of communication; Even how to cooperate with Japanese manufacturers in the future is quite difficult. In the process, several manufacturers failed to reach the standards and ruined the contract. The above things once made me want to give up, but I thought that there is the opportunity to increase the added value of the products produced in the Taiwan factory, which is a two-pronged approach.

Good things are easily tormented, and after the hardship of research and development, we had finally completed this difficult task.

The follow-up market news also made everyone very excited.

In the original Taiwan 20 pre-orders, the pre-order price was slightly lower than the normal sales price. When the prototype proofing photos were exposed, I didn't expect the pre-ordered crowds to be full, and People even would like to order them at the original price. The gallery also urgently transferred the quota from Japan, which made us very excited.

Following the JET Silver in 2015, JET Gold also launched a whirlwind in Taiwan in 2016.

It even touched the art toy collection market in Hong Kong and Taiwan. Begin to let this market group enhance the collection energy into the pure art collection field.

This was what we didn't expect at the beginning.

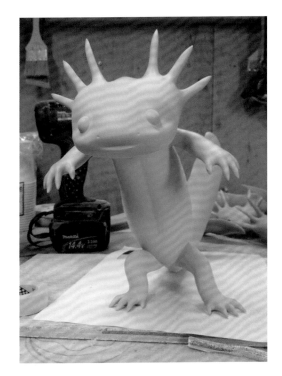

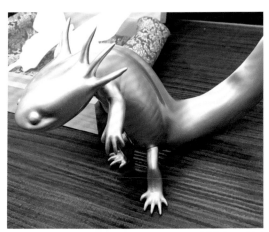

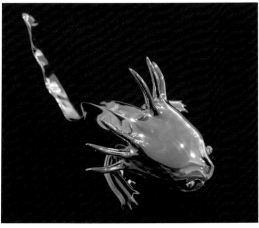

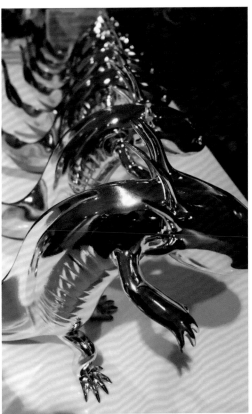

Phototype of J.E.T.
J.E.T. 2015
J.E.T.GOLDEN 2016

為何以
salamander
創作

2013年畫廊在發掘他的當時，他是全球唯一以salamander為主題創作的藝術家，為何會以salamander為創作源頭？

這就得從他的太太說起，井上在畢業後幾年在創作上一直有著瓶頸，找不到自己的創作核心，所以一直無法受到藝術市場的青睞。

卻也因為婚後要負起養家問題，而去了一家製作墓碑的工坊上班，而太太在醫院擔任護理工作，當時生活看似平穩，但是井上因為創作無法受到認同而鬱鬱寡歡。

一日他的一位學長透漏一個歐洲雕塑研習營的機會給他，對當時創作瓶頸的他來說真是天降甘霖。但礙於現實生活，讓他陷入兩難。

他私下曾與工坊的老闆商量，希望老闆能讓他請長假，去歐洲研習。但是老闆希望他能為自己的人生下定決心"若是你想要這份工作，就心無旁鶩的做下去。

如果你要請假去歐洲，那就不要回來了!"
老闆這樣的告訴他。

困擾一段時間後，他還是跟太太商量了…

只見井上的太太很爽朗的說:我是嫁給一位藝術家，而不是嫁給刻墓碑的工人。家裡的事情就交給我，你專心的去歐洲研習。她非常堅決的支持著…

因為這樣的後盾，再度開啟了他創作之路。

歐洲研習期間，井上第一次在義大利的公共建築中看到許多精美的石雕像，讓他非常的衝擊與憧憬。尤其在人像的腳下大多會有爬蟲類的石雕，非常的精美，卻沒有人去注意到，反而成為他後續創作核心的一個開關。

偶遇的一隻蜥蜴，美麗的線條讓井上思索起生物進化，進而將salamander成為闡釋創作的載體，刻劃動人文化內容。

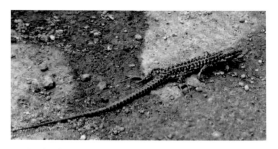

井上在義大利研習時巧遇的美麗蜥蜴，
也成為他創作的繆思。

Why create with salamander?

When the gallery was exploring him in 2013, he was the only artist in the world who created the theme of salamander.

Why is salamander as the source of creation? I have to talk about the story of INOUE and his wife. In the past few years after graduation, Inoue has always had a bottleneck in his creation and could not find his own creative core, so he has been unable to be favored by the art market.

But because of the problem of raising a family after marriage, he got a job in a workshop where tombstones were made, and his wife worked as a nurse in the hospital. At that time, the living economy seemed to be stable, but INOUE was unhappy because the creation could not be recognized.

One day, one of his seniors gave him a chance to learn from a European sculpture camp. It was really a God-given opportunity for him who was at the bottleneck of creation. But because of real life, he is caught in a dilemma. He privately discussed with the boss of the workshop, hoping that the boss can let him take a long vacation and go to Europe to study. But the boss wants him to make up his mind for his career. "If you want this job, do it with no hesitation. If you want to take time off to Europe, then don't come back!" The boss told him .

After a while, he still discussed with his wife... Mrs. Inoue said very heartily: "I am marrying an artist, not a worker who is engraved with a tombstone. Leave everything up to me and You concentrate on studying in Europe." She is very determined to support... Because of this backing, he once again opened the way of his creation. During the European study, Inou was the first to see many beautiful stone statues in the public buildings of Italy, which made him very shocked and embarrassed. Especially at the feet of portraits, most of them have reptile stone carvings, which are very beautiful, but no one notices them. Instead, they become a switch for the core of his subsequent creation. The encounter with a lizard, the beautiful lines let INOUE think about the evolution of biology, and then the salamander becomes a carrier to explain his creation, and to engrave the cultural content.

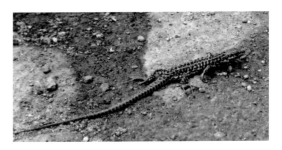

The lizard in Italy inspired to his creation.

石雕-最原始的人生凝視

藝術家早期以純色大理石創作出可視可觸的藝術形象，
試著反映和表達藝術家的美感,及人生的重量。

Stone carving – the most primitive gaze on life

In the early period, the artist created a visually touchable artistic
image with solid color marble, trying to reflect and express the
artist's aesthetic sense and the weight of life.

石雕

PLANET
Marble
H30xW30xD30
2002

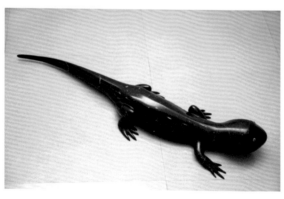

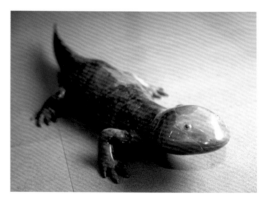

stone salamander
Marble
H9xW78xD23
2003

stone salamander
Marble
H10xW80xD23
2003

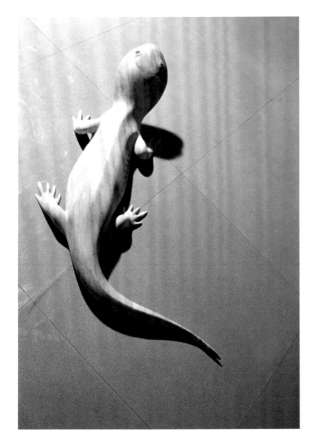

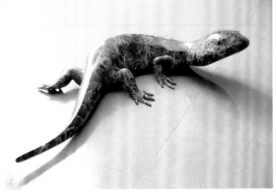

stone salamander
Marble
H18xW59xD30
2003

stone salamander
Marble
H14xW85xD25
2003

stone salamander
Marble
H14xW58xD33
2003

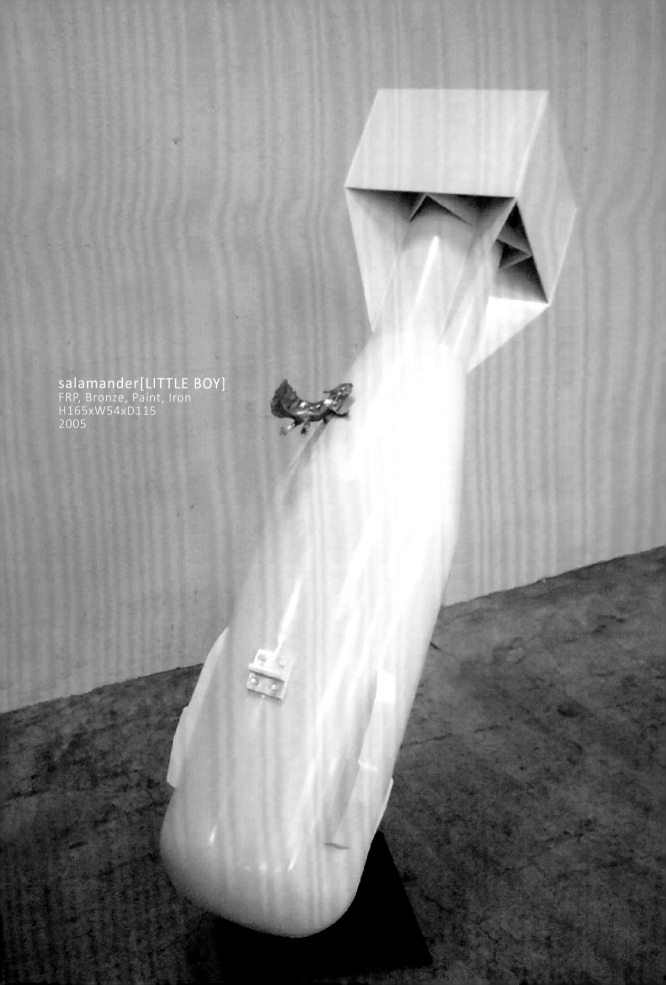

salamander[LITTLE BOY]
FRP, Bronze, Paint, Iron
H165xW54xD115
2005

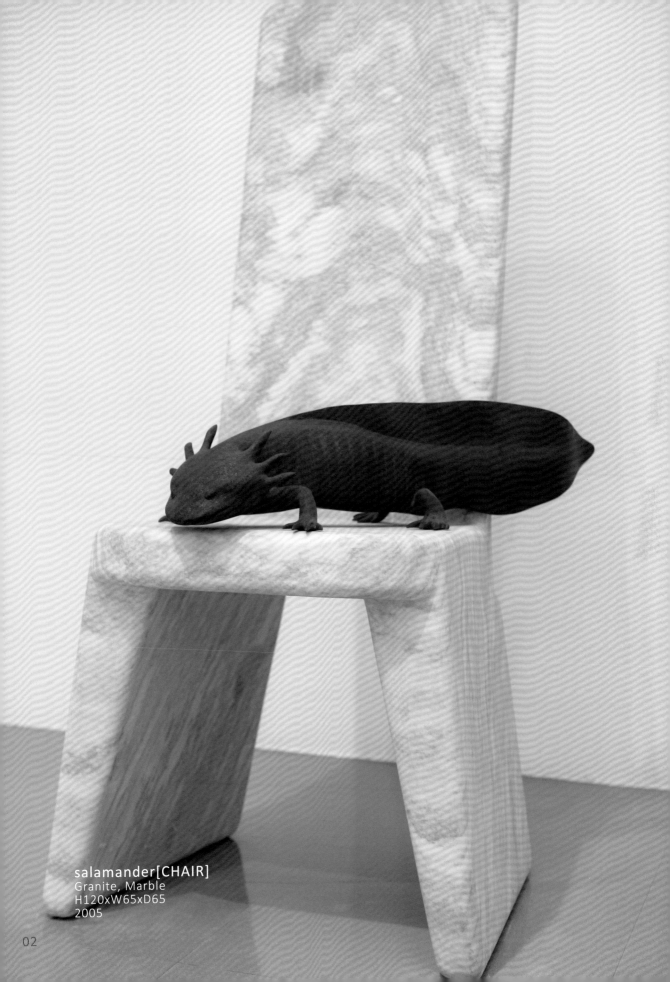

salamander[CHAIR]
Granite, Marble
H120xW65xD65
2005

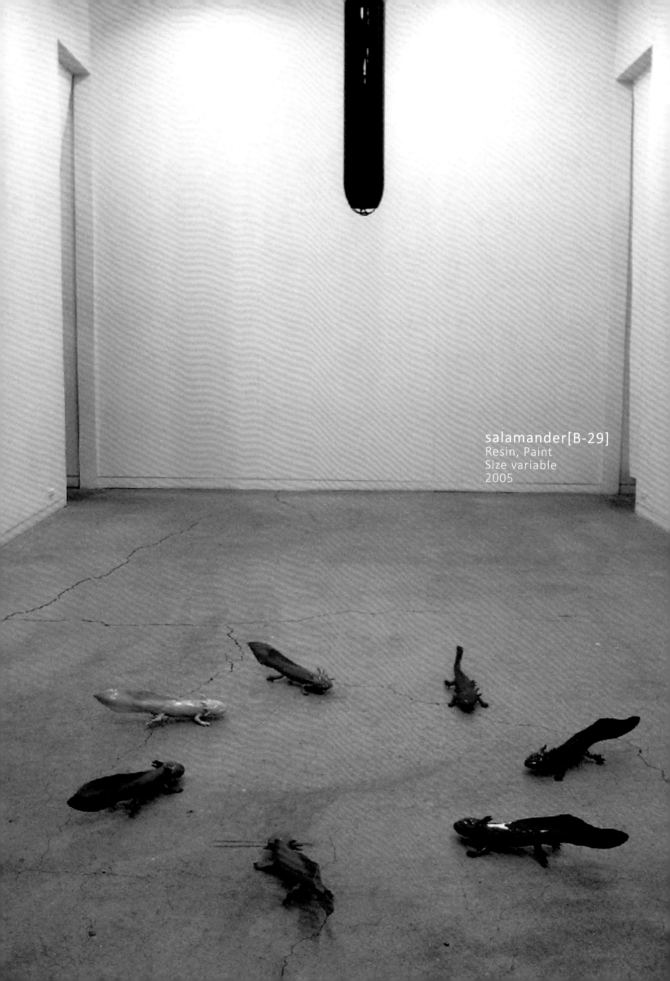

salamander[B-29]
Resin, Paint
Size variable
2005

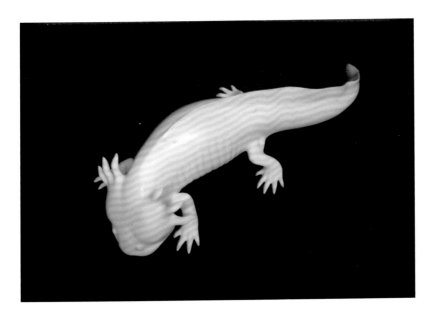

stone salamander
Marble
H18x W65x D30
2007

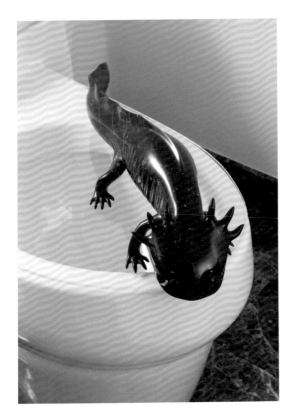

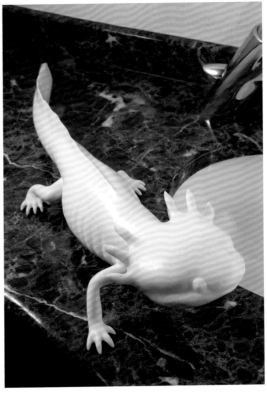

stonesalamander
Marble
H14xW17xD38
2008

stonesalamander
Marble
H12xW19xD40
2008

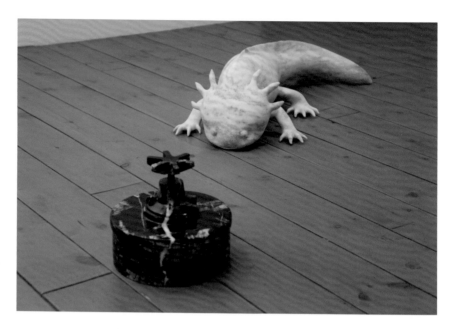

stone salamander
Marble
H15xW64xD36
2008

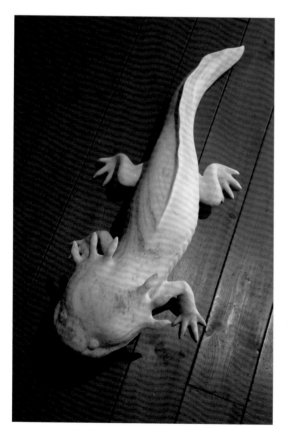

stone salamander
Marble
H18xW68 xD35
2008

stone salamander
Marble
H16xW65xD35
2008

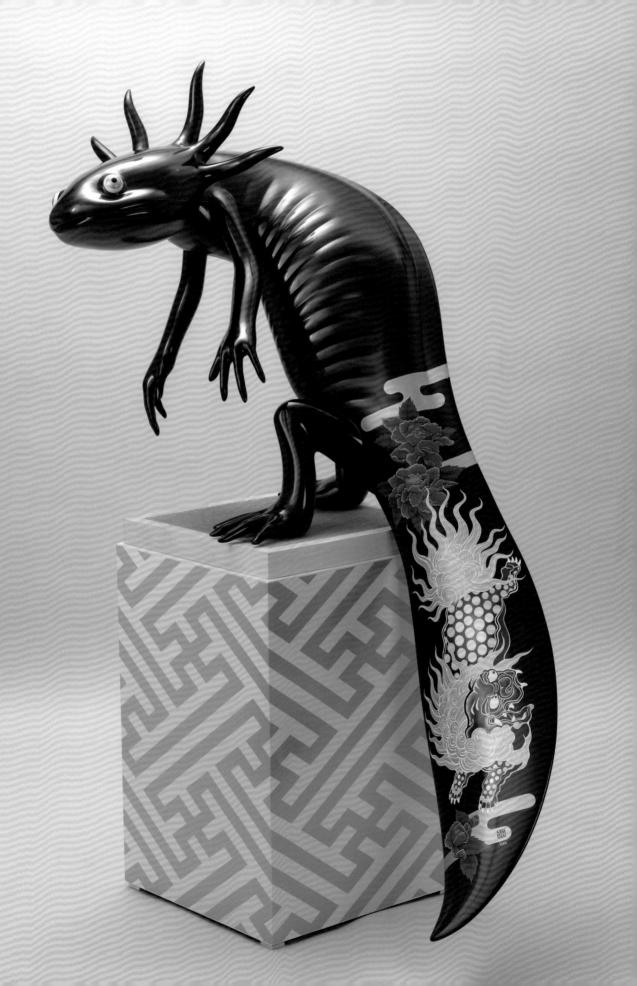

和彫
從捨棄世道到開拓希望

[IREZUMI/刺青] 是Tattoo的日文意思，在日本自成一格的演進。
這種傳統的風格稱為"和雕"，很多人會將它跟所謂黑社會聯想，
但難掩其精細美麗的質感。
兩棲類的進化過程，從水中到陸地進入未知的世界，
而透過刺青表現意味著捨棄一般世道的覺悟，
這種捨棄的行為看似一霎那，
但如此舉動也為自己的生存之道開拓無限的希望。

IREZUMI(Tatoo)
From abandoning the world to developing hope

IREZUMI means Tattoos in Japanese, which has unique evolution in Japan.
This traditional style is called 和彫, many people connect it with gangs,
but it does not hide its beautiful and fine texture.
Evolution of amphibians from water to land into the unknown world,
and through tattoos to present the meaning of discarding the general
morals consciousness , this discarding behavior seems only in a moment,
but such a move also open unlimited hope for their survival.

刺青

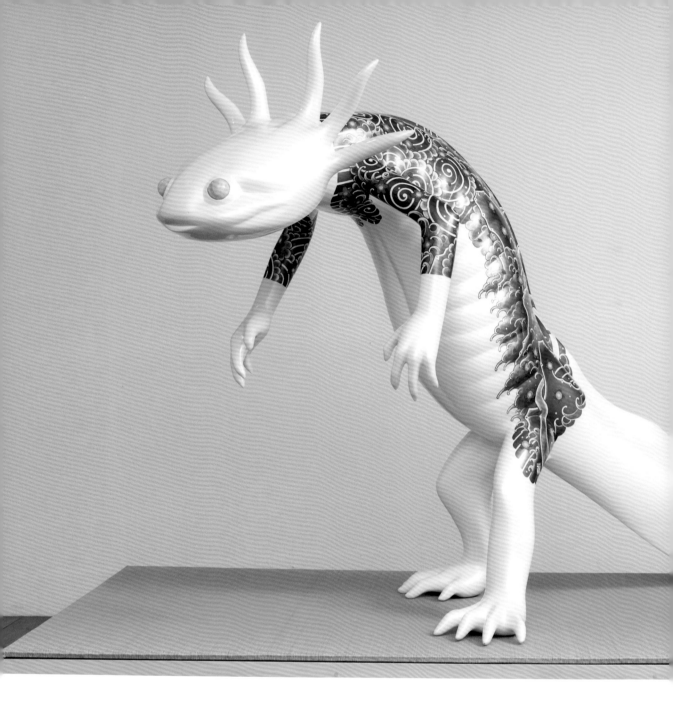

48

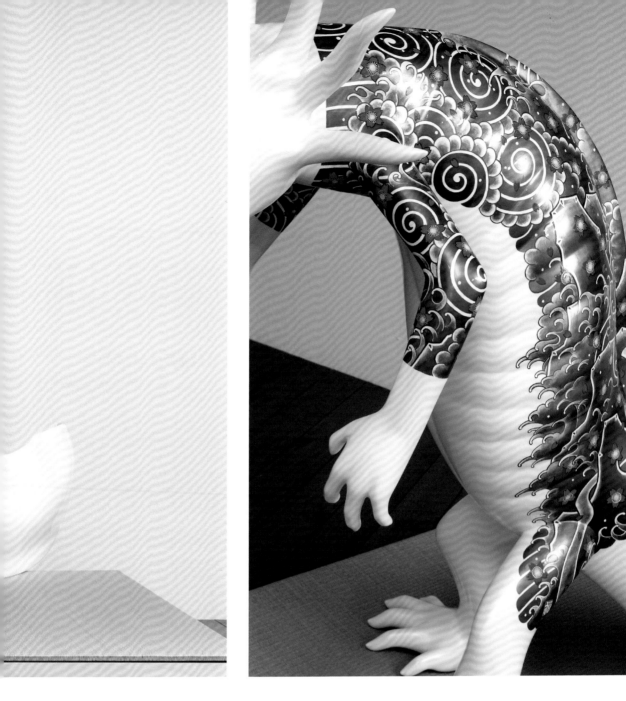

salamander[IREZUMI]
FRP, Paint, Wood, Tatami mat
H110xW190xD60
2009

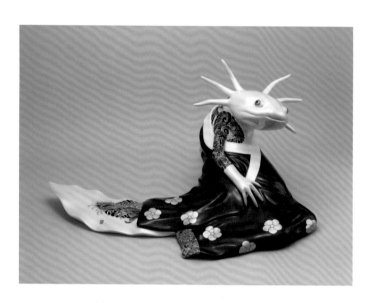

salamander[OIRAN]
FRP, Marble, Paint, Tatamimat, Wood, Japanesepaper
H200xW250xD250
2010

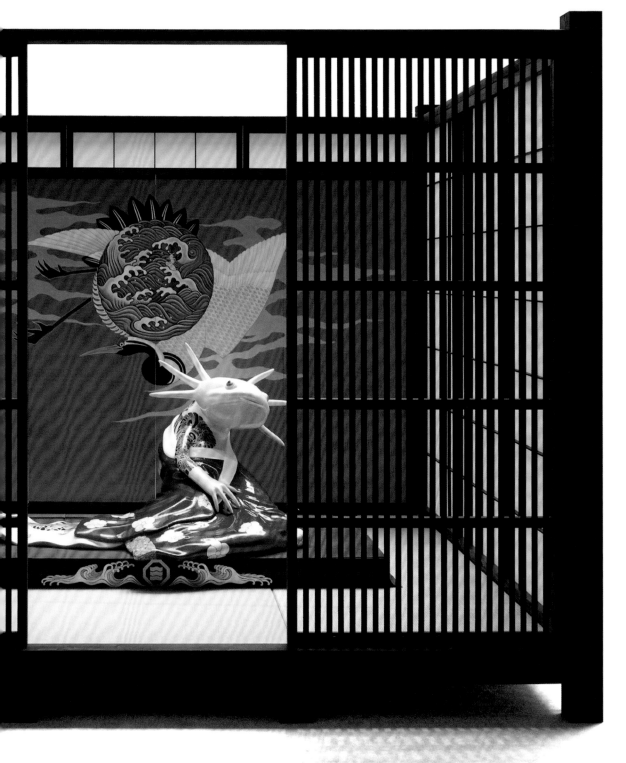

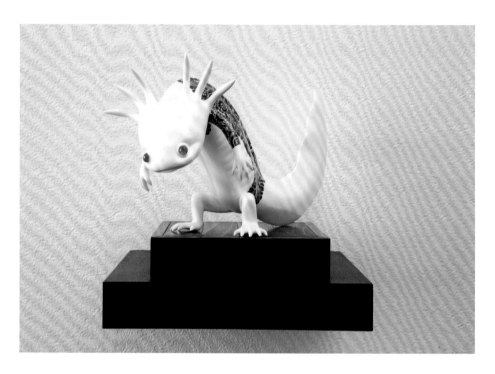

salamander[IREZUMI]
FRP, Paint, Wood
H29xW37xD14
2008

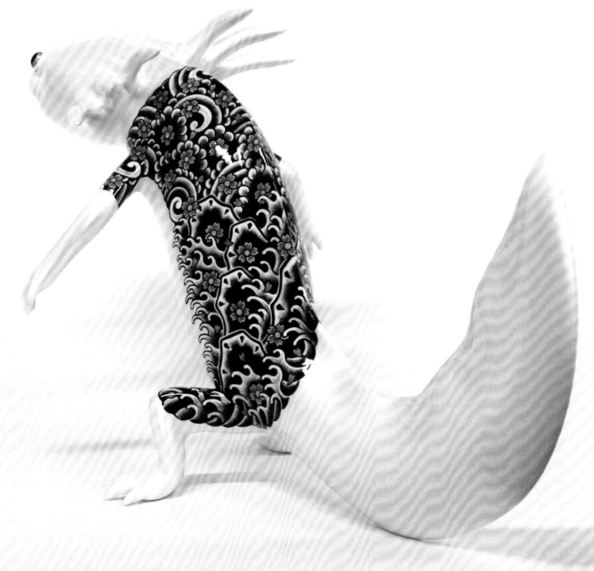

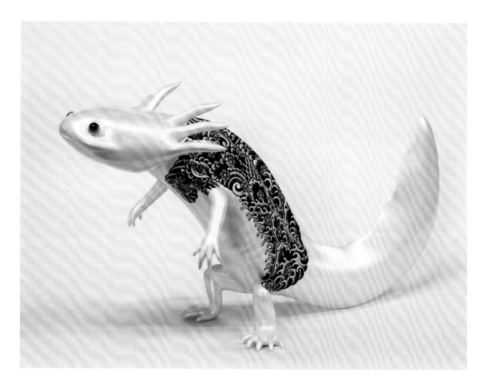

salamander[IREZUMI]
FRP, Paint
H22xW18xD39
2012

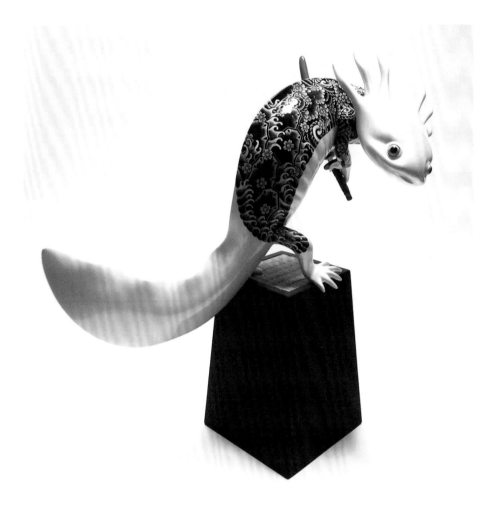

salamander[IREZUMI]
FRP, Paint, Wood, Mat
H42xW37xD20
2013

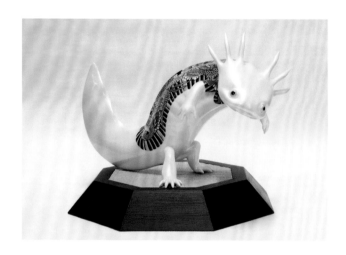

salamander[IREZUMI]
FRP, Paint, Wood, Mat
H23xW29xD30
2015

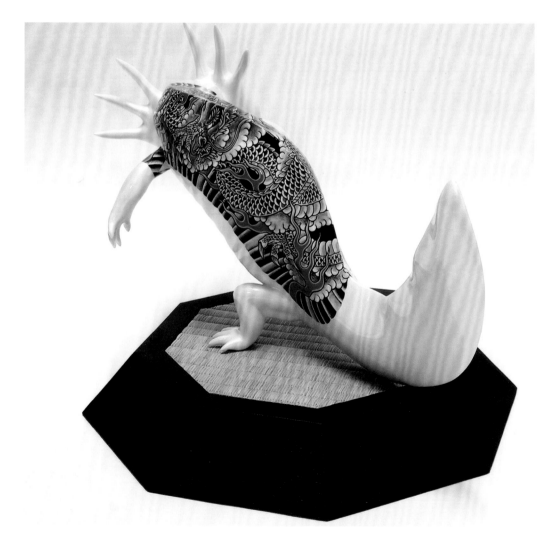

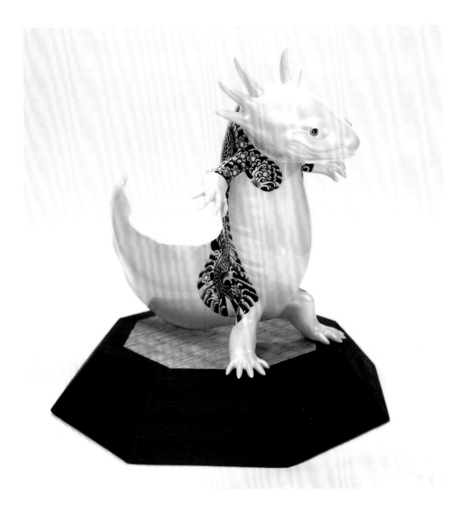

salamander[IREZUMI]
FRP, Paint, Wood, Mat
H22x W27x D25
2017

かぶき Kabuki

那種服飾華麗且配有奇異裝飾,同時異於常人的行為,
充滿能量和活力的動作...
歌舞伎以其獨特的集歌、舞、演劇為一身的豪華妖豔的風格,
至今已走過了400多年,為日本國粹的古老傳統藝術。

With the costume gorgeous and has strange decorations,
The one is different from the behavior of ordinary people,
full of energy and vitality.... Kabuki has gone through the unique
style of singing, dancing and acting. For more than 400 years,
it is the ancient traditional art of the Japanese national quintessence.

歌舞伎

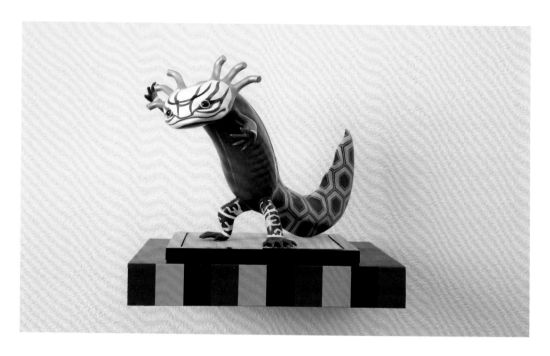

salamander[KABUKI]
FRP, Paint, Wood, Mat
H31xW37xD30
2008

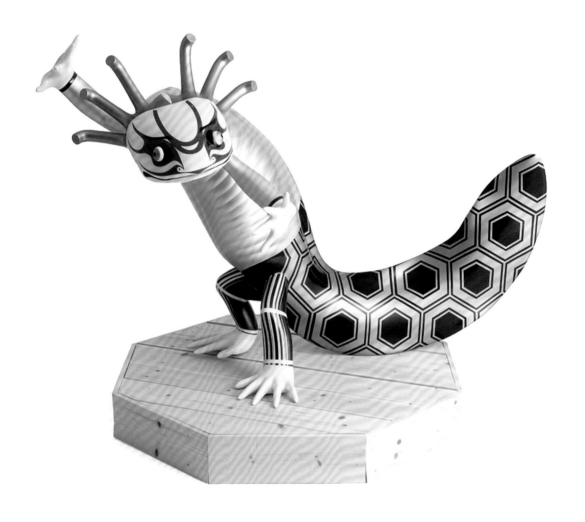

salamander[KABUKI]
FRP, Paint, Marble, Wood
H146xW192xD125
2010

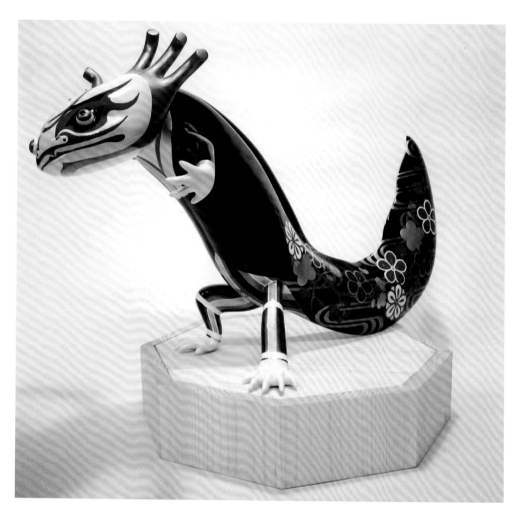

salamander[KABUKI]
FRP, Paint, Wood
H31xW37xD18
2010

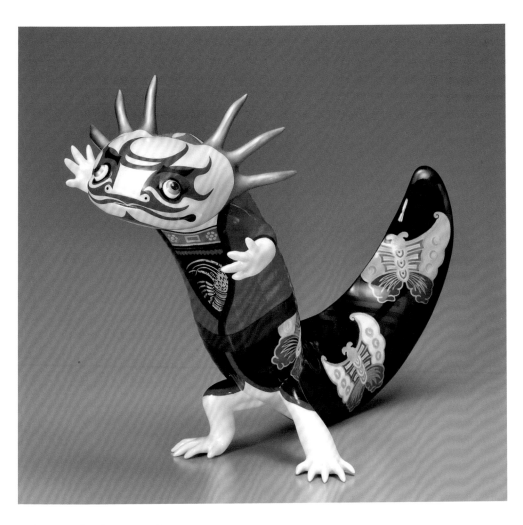

salamander[KABUKI]
FRP, Paint
H23xW37xD16
2014

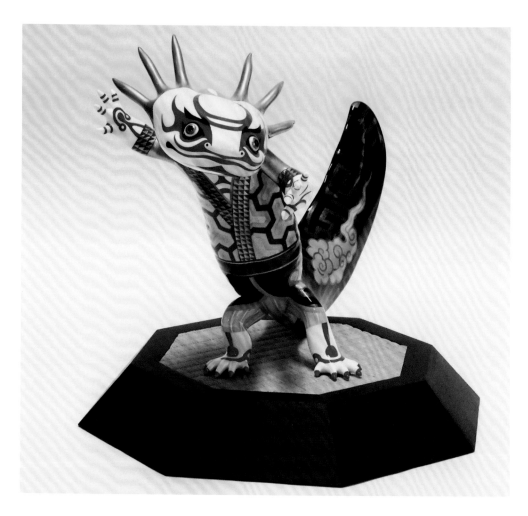

salamander[KABUKI]
FRP, Paint, Wood, Mat
H30xW35xD17
2015

salamander[KABUKI]
FRP, Paint
H22xW23xD13
2018

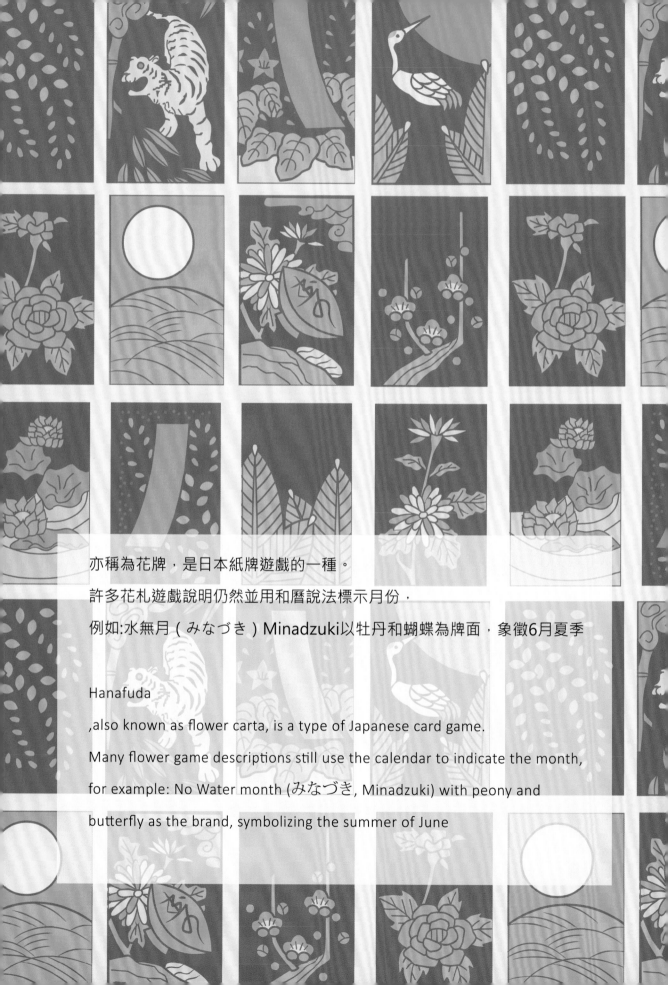

亦稱為花牌，是日本紙牌遊戲的一種。

許多花札遊戲說明仍然並用和曆說法標示月份，

例如:水無月（みなづき）Minadzuki以牡丹和蝴蝶為牌面，象徵6月夏季

Hanafuda

,also known as flower carta, is a type of Japanese card game.

Many flower game descriptions still use the calendar to indicate the month,

for example: No Water month (みなづき, Minadzuki) with peony and

butterfly as the brand, symbolizing the summer of June

花札

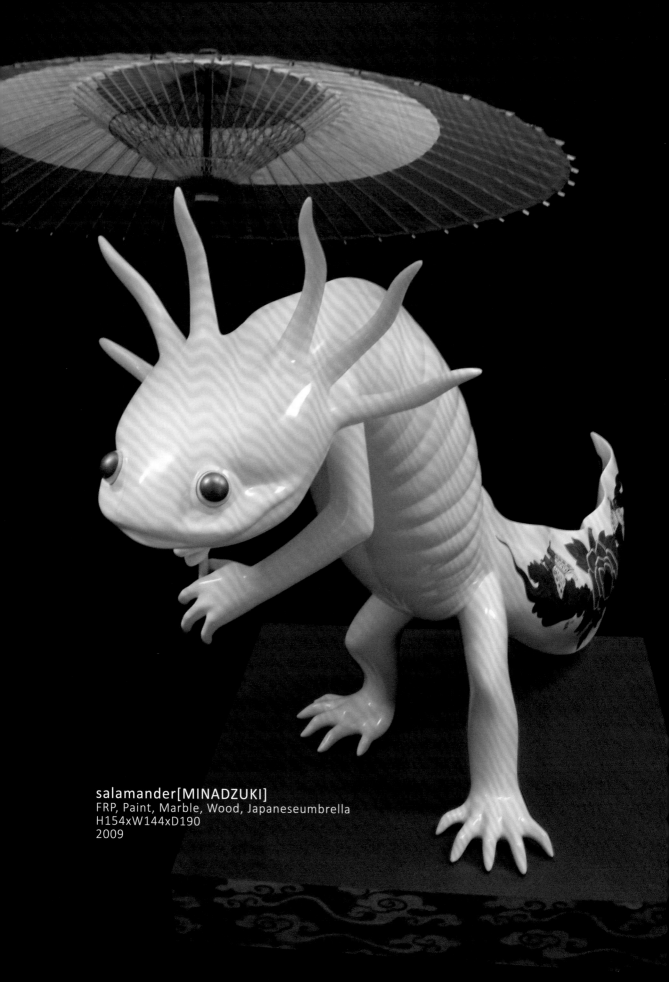

salamander[MINADZUKI]
FRP, Paint, Marble, Wood, Japaneseumbrella
H154xW144xD190
2009

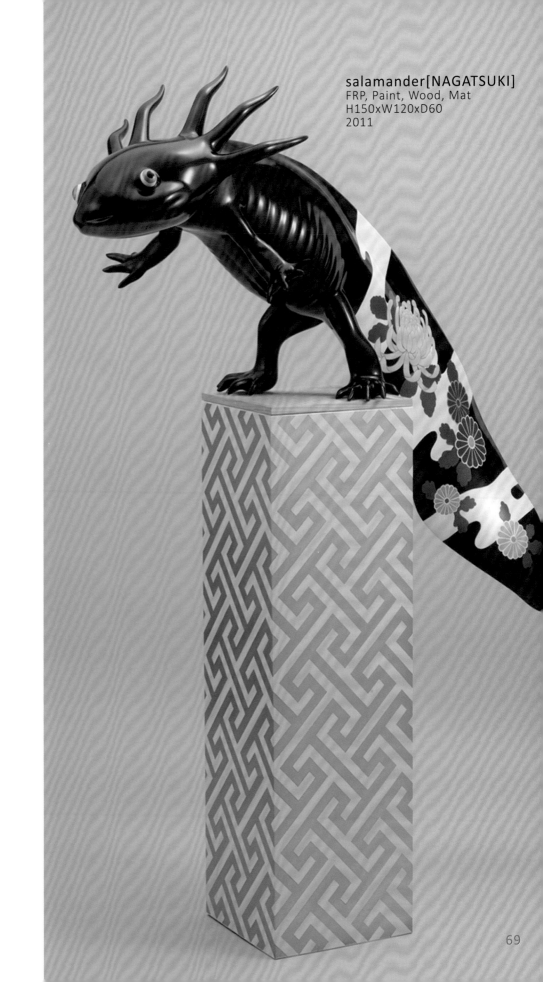

salamander[NAGATSUKI]
FRP, Paint, Wood, Mat
H150xW120xD60
2011

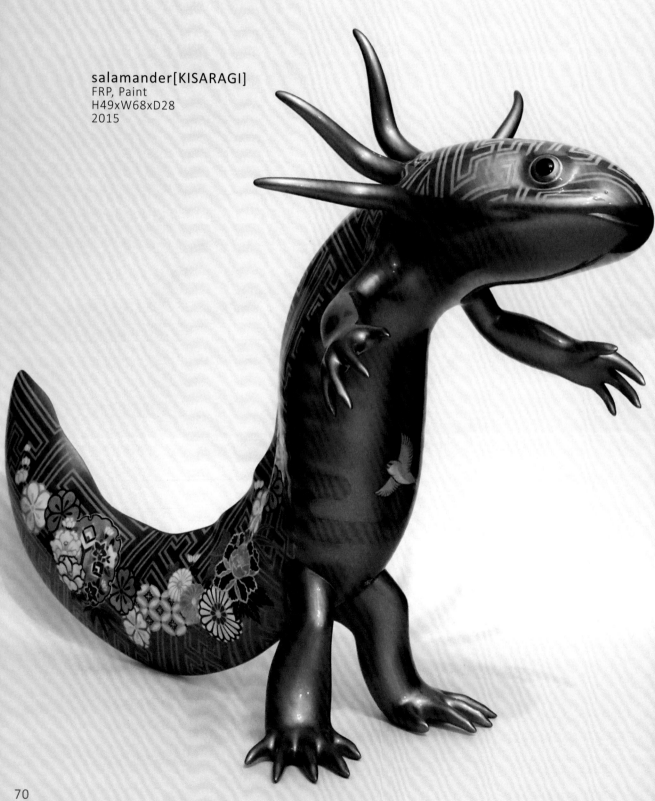

salamander[KISARAGI]
FRP, Paint
H49xW68xD28
2015

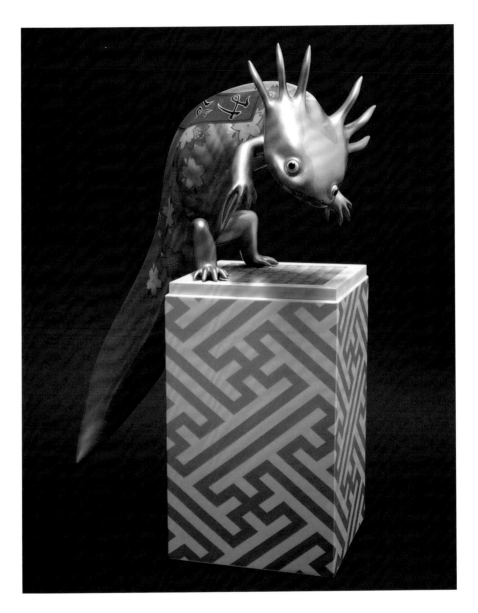

salamander[YAYOI]
FRP, Paint, Mat, Wood
H43xW19xD32
2015

浮世繪（ukiyo-e）描繪世間風情，可以是人的日常生活、
風景、戲劇或人物，是日本獨特的民間藝術和風俗畫。

興起於17世紀的江戶時代，注重描繪人們的生活，
因此能夠引起大眾的共鳴。

Ukiyo-e depicts the world, can be a person's daily life, scenery,
drama or characters, is a unique Japanese folk art and genre painting.

Ukiyo-e was born in the Edo period in the 17th century,
focusing on depicting people's lives, and thus can resonate with the public.

浮世絵

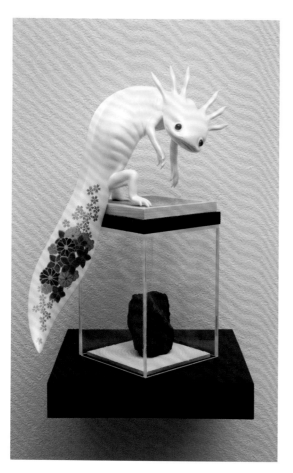

salamander[WA]
FRP, Paint, Acrylic,
Stone, Mat
H44x W22x D35
2008

salamander[WA]
FRP, Paint, Acrylic,
Stone, Mat
H44x W22x D35
2008

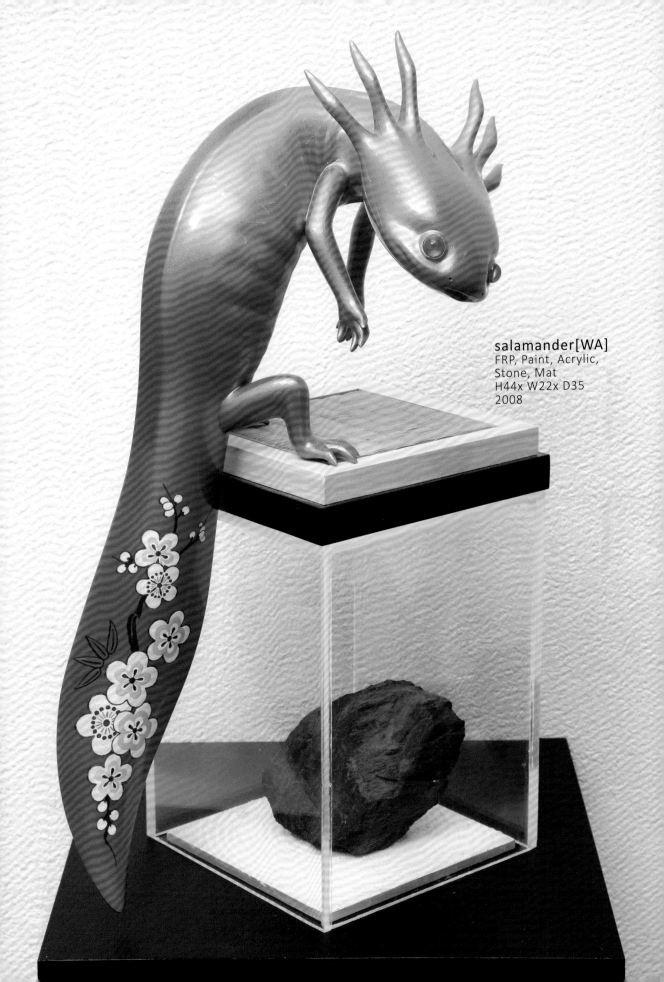

salamander[WA]
FRP, Paint, Acrylic,
Stone, Mat
H44x W22x D35
2008

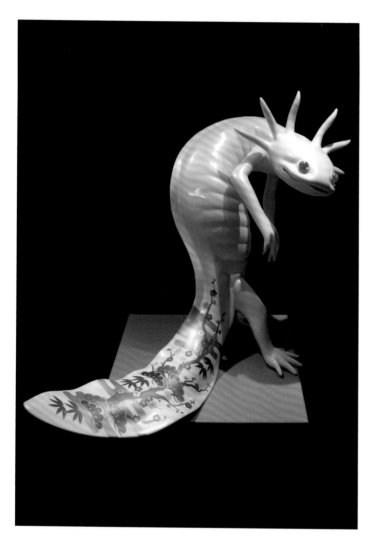

salamander[SYOCHIKUBAI]
FRP, Paint, Mat, Wood
H120xW150xD120
2009

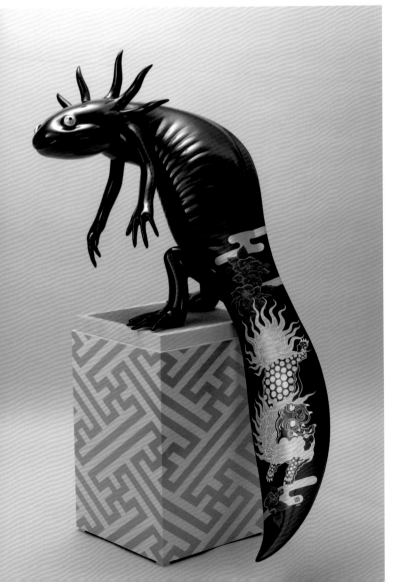

salamander [KARAJISHIBOTAN]
FRP, Paint, Wood, Mat
H165x W125x D75
2009

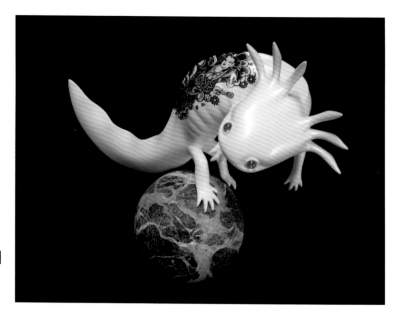

salamander[BENTEN]
FRP,Acrylic,Marble,Paint
H37xW40xD16
2009

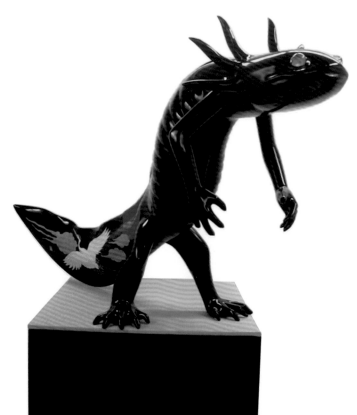

salamander[TSURUKAME]
FRP, Paint, Mat, Wood
H110xW195xD60
2009

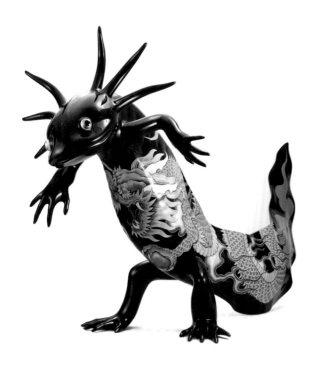
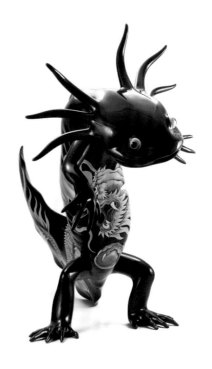

salamander[DRAGON]
FRP, Marble, Paint
H190xW150xD330
2011

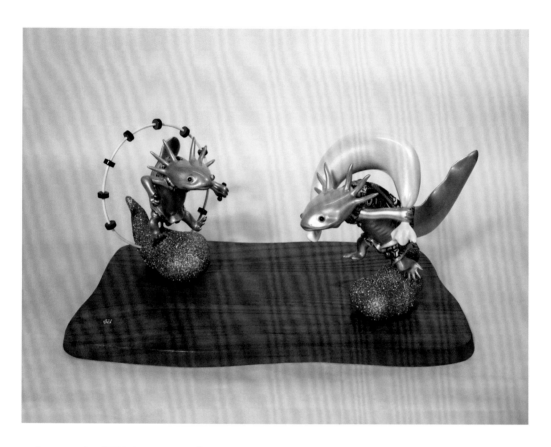

salamander[FUJIN-RAIJIN]
FRP, Paint, Wood, Iron
H18xW36XD25
2013

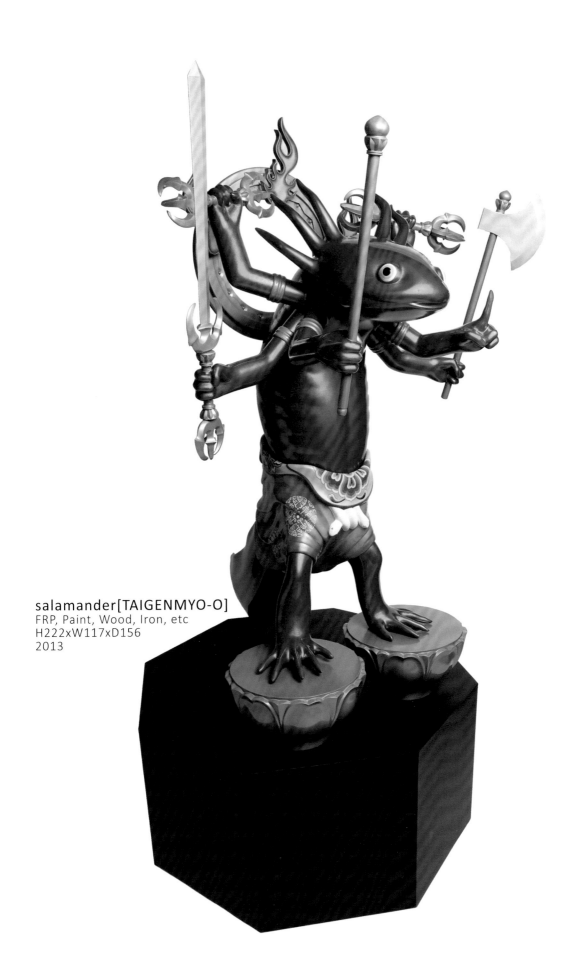

salamander[TAIGENMYO-O]
FRP, Paint, Wood, Iron, etc
H222xW117xD156
2013

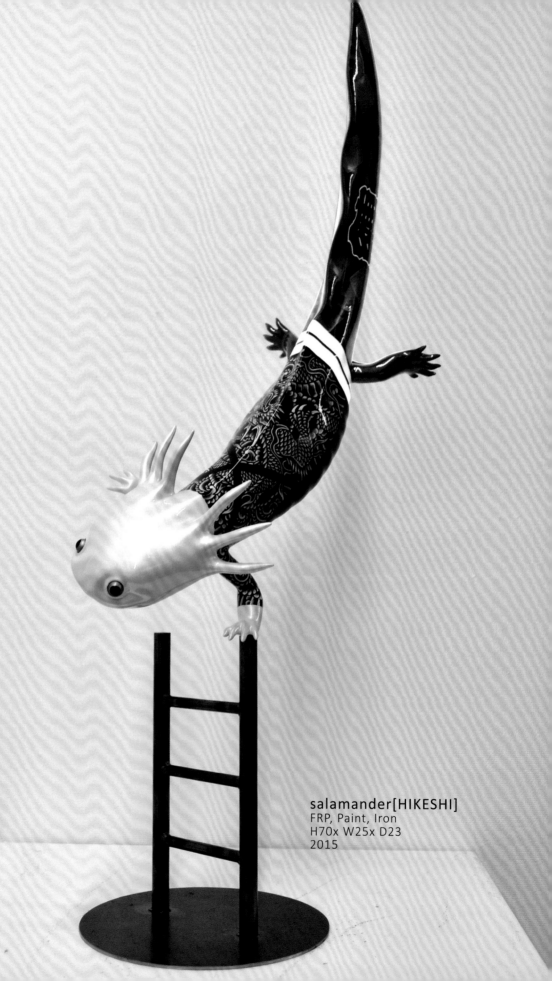

salamander[HIKESHI]
FRP, Paint, Iron
H70x W25x D23
2015

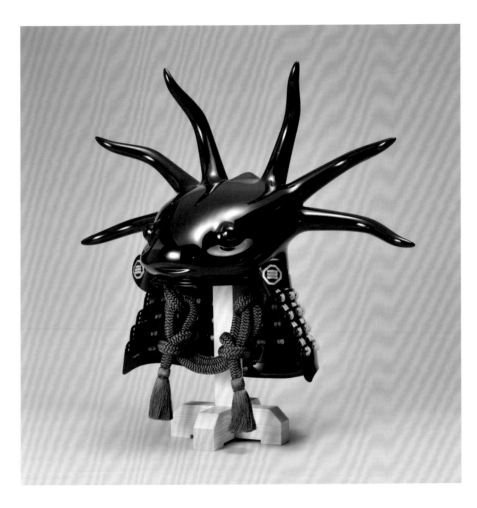

山椒魚形兜
The Helmet of Salamander Shape
FRP, Paint, Iron, Braiding
H65xW34xD60
2016

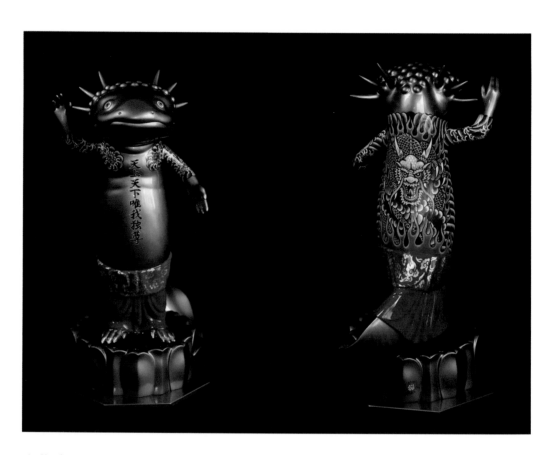

山椒魚誕生仏
FRP, Paint
H32xW17xD18
2017

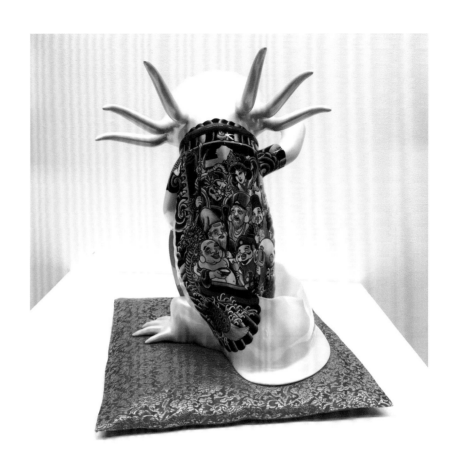

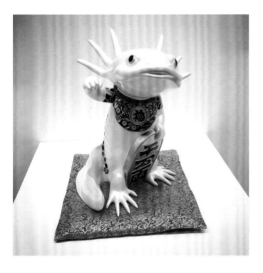

招福山椒魚
FRP, Paint, Cloth
H36xW30x35
2017

salamanDharma
FRP, Paint, Tatami mat
H27xW25xD25
2017

salamanDharma
FRP, Paint, Tatami mat
H27xW25xD25
2017

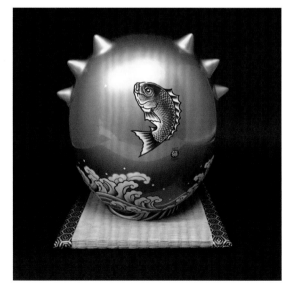

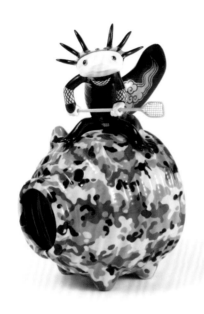

salamander[KILLER MACHINE]
FRP, Paint,
Pig shaped mosquito holder
H22,5xW14,5xD14
2018

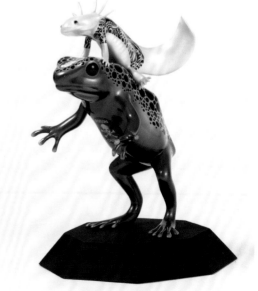

salamander[騎蛙像]
FRP, Paint, Wood
H29,5xW21xD21
2018

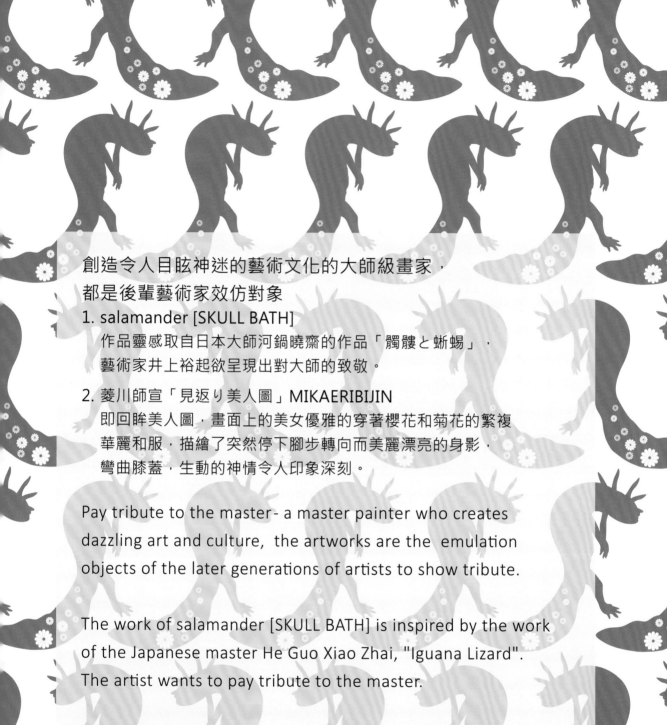

創造令人目眩神迷的藝術文化的大師級畫家，
都是後輩藝術家效仿對象
1. salamander [SKULL BATH]
 作品靈感取自日本大師河鍋曉齋的作品「髑髏と蜥蜴」，
 藝術家井上裕起欲呈現出對大師的致敬。
2. 菱川師宣「見返り美人圖」MIKAERIBIJIN
 即回眸美人圖，畫面上的美女優雅的穿著櫻花和菊花的繁複
 華麗和服，描繪了突然停下腳步轉向而美麗漂亮的身影，
 彎曲膝蓋，生動的神情令人印象深刻。

Pay tribute to the master- a master painter who creates
dazzling art and culture, the artworks are the emulation
objects of the later generations of artists to show tribute.

The work of salamander [SKULL BATH] is inspired by the work
of the Japanese master He Guo Xiao Zhai, "Iguana Lizard".
The artist wants to pay tribute to the master.

The Hiroshi Shisuke's " MIKAERIBIJIN" is a picture of
the beauty.
The beautiful woman in the elegant dress is wearing a gorgeous
 kimono of cherry blossoms and chrysanthemums, depicting a
beautiful figure that suddenly stops and turns, and bends the
knees, and the vivid look is impressive.

向大師致敬

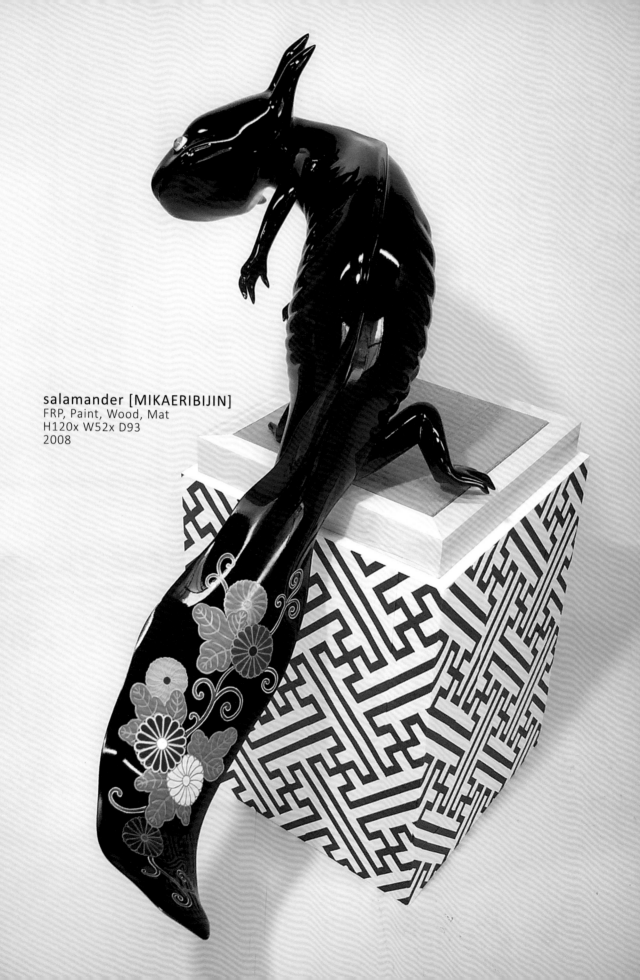

salamander [MIKAERIBIJIN]
FRP, Paint, Wood, Mat
H120x W52x D93
2008

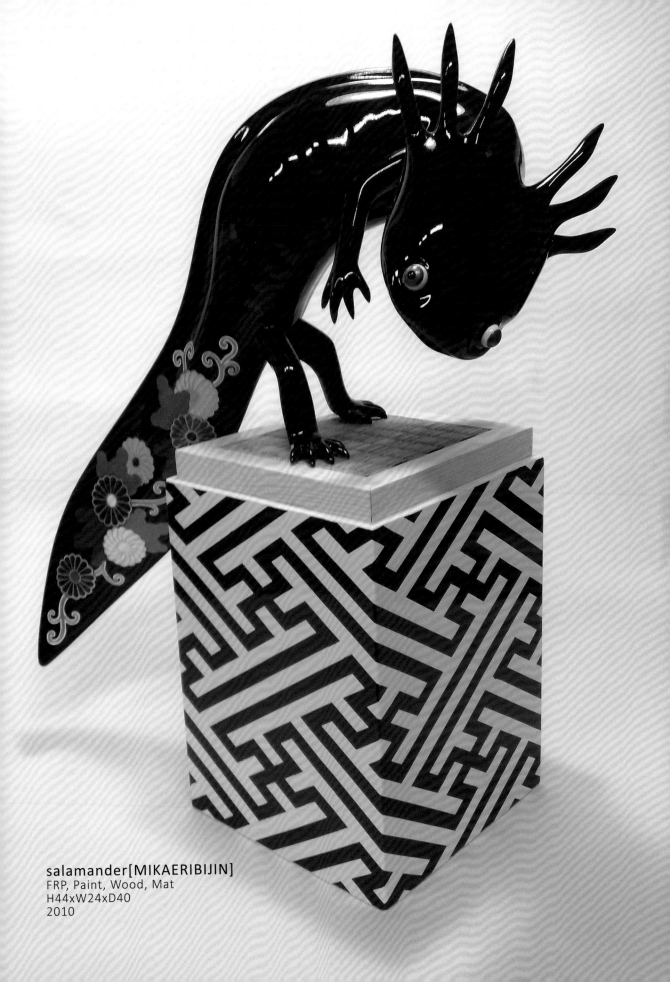

salamander[MIKAERIBIJIN]
FRP, Paint, Wood, Mat
H44xW24xD40
2010

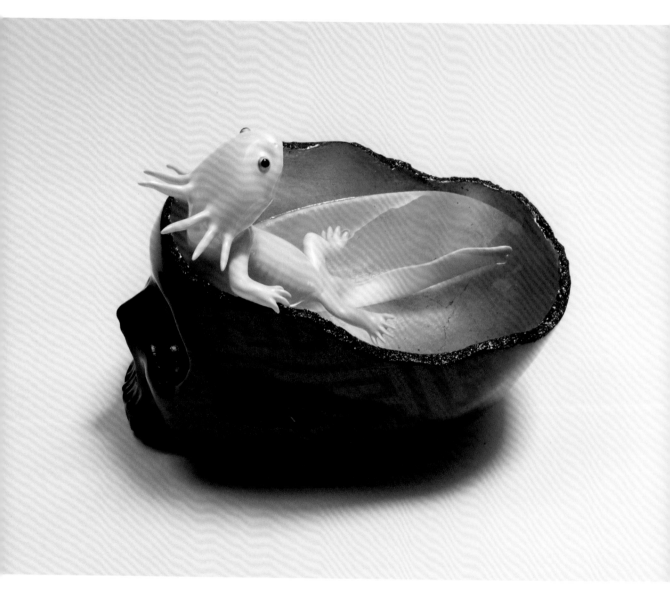

salamander[SCULL BATH]
FRP, Paint, Transparent plastic
H15,5x W20x D13,5
2015

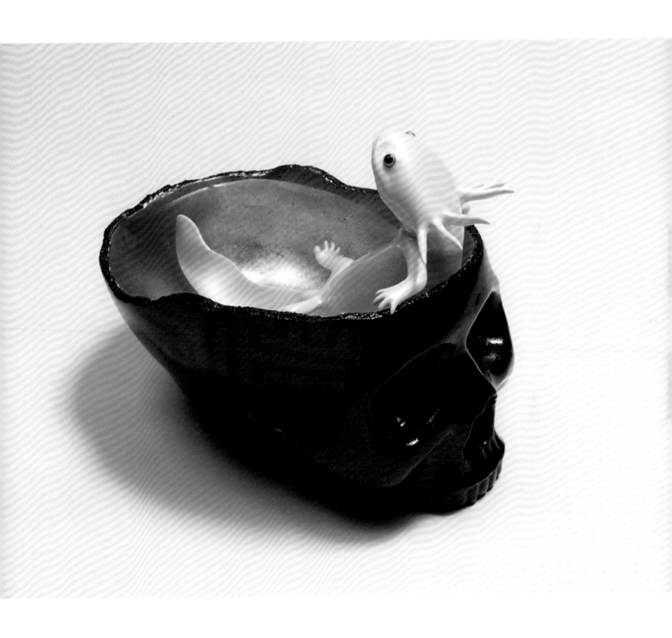

日本卡漫定義了近40年的二維視覺靜態圖畫藝術，可愛，俏皮或令人莞爾的風格已深刻影響當代藝術發展。

Japanese Cartoon & Comic define the art of two-dimensional visual static painting for nearly 40 years. The cute, playful or pleasant style has profoundly influenced the development of contemporary art.

卡漫

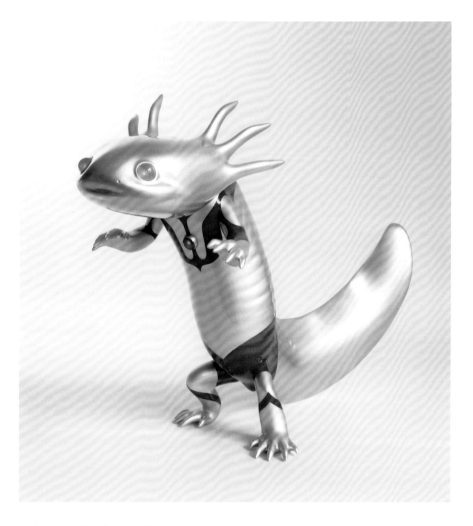

salamander[HERO]
FRP, Paint
H25xW36xD15
2013

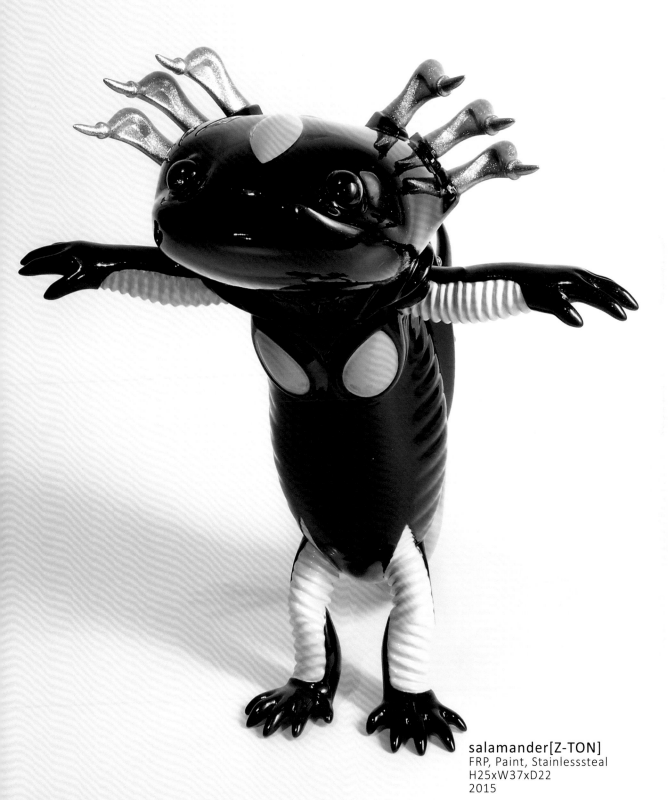

salamander[Z-TON]
FRP, Paint, Stainlesssteal
H25xW37xD22
2015

©TSUBURAYA PRODUCTION

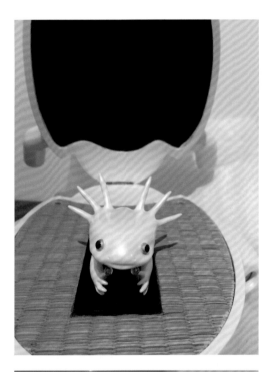

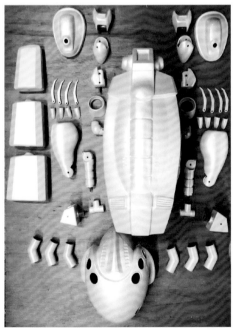

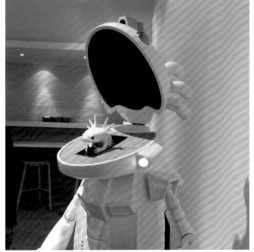

salamander[ROBOT]
FRP, Paint
H66xW36xD66
2016

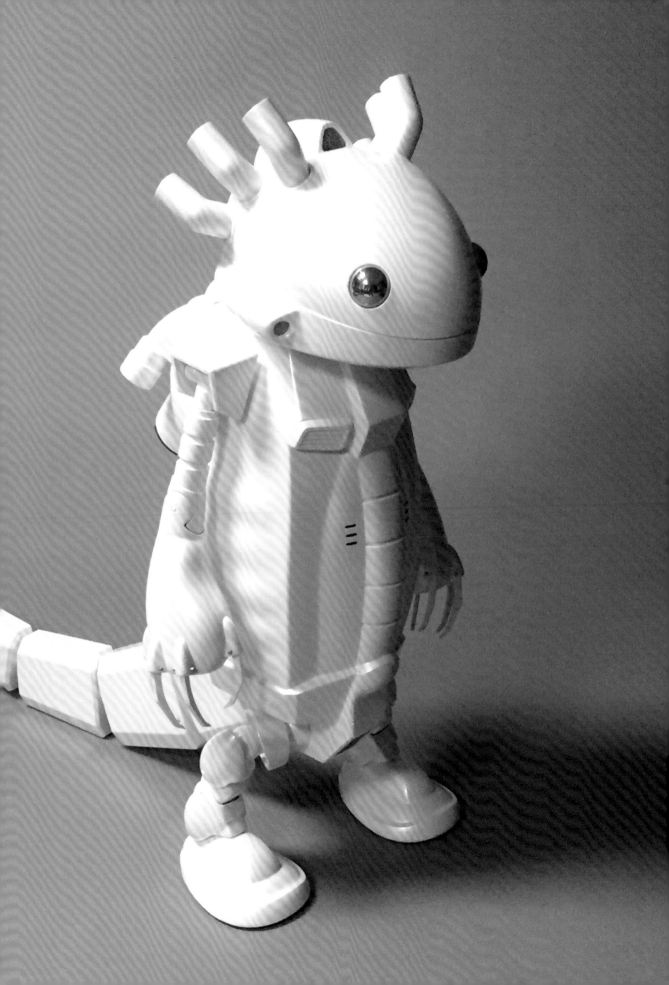

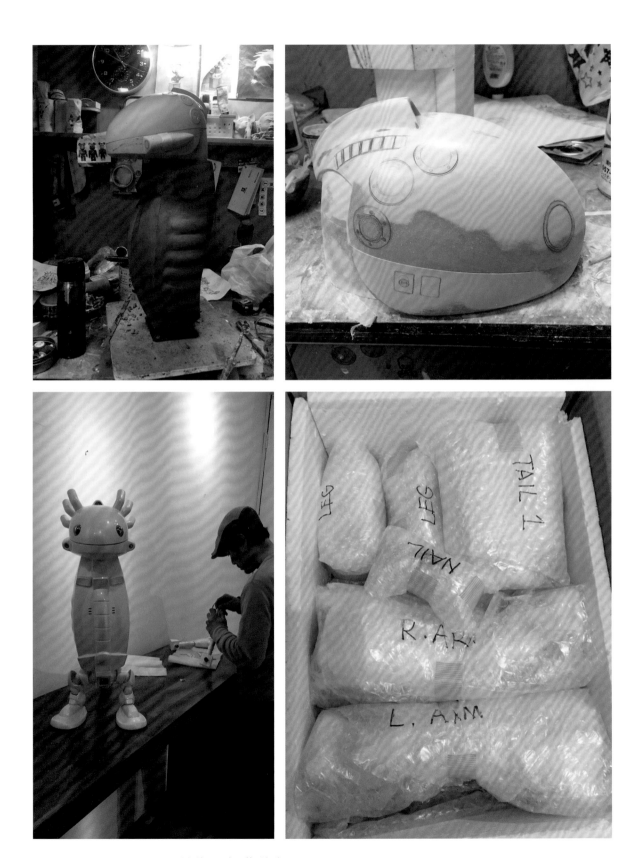

salamander[ROBOT] 製作、組裝花絮

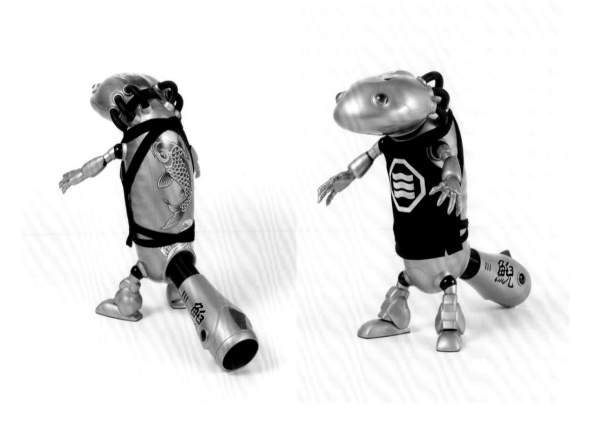

salamander[ROBOT]
FRP, Paint, Cloth
H45xW50xD32
2018

風格百錦

創意俯拾可得

Diverse Styles
Creativity everywhere can be seen in his works

風格百錦

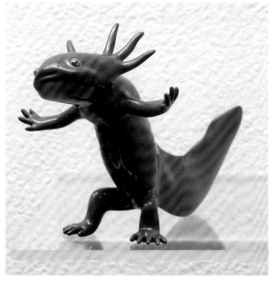
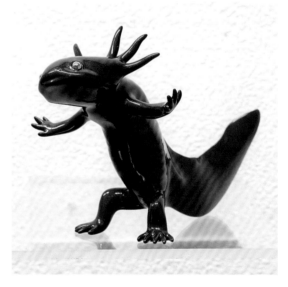

salamander[RAINBOW]
FRP, Paint
H11xW20xD11
2011

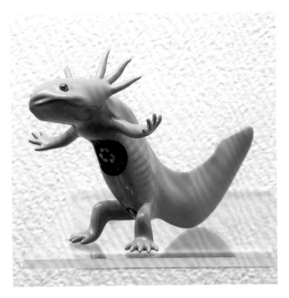
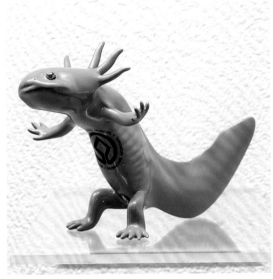
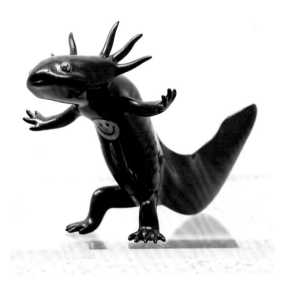
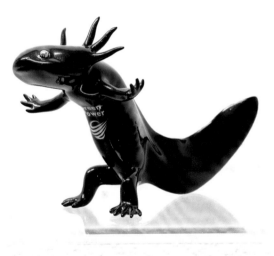

salamander[RAINBOW]
FRP, Paint
H11xW20xD11
2011

salamander[PHOENIX]
FRP, Paint, Marble
H28xW22xD32
2011

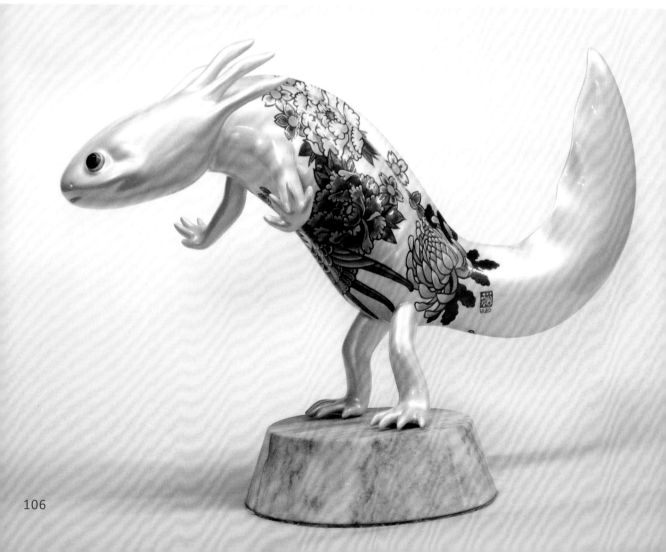

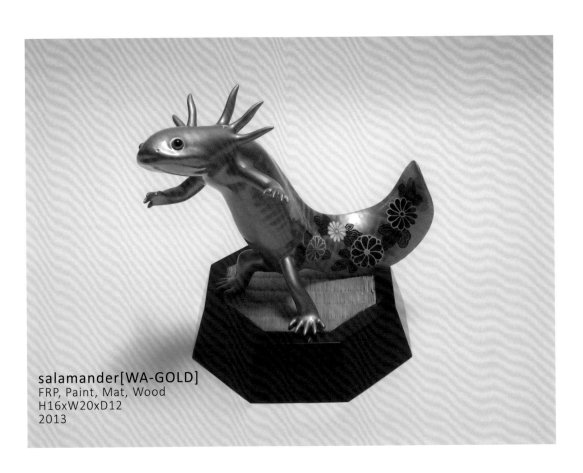

salamander[WA-GOLD]
FRP, Paint, Mat, Wood
H16xW20xD12
2013

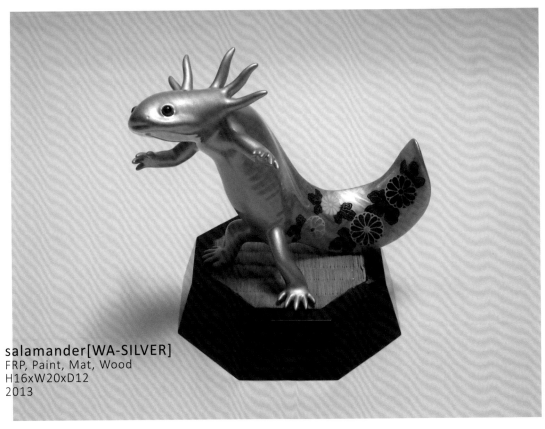

salamander[WA-SILVER]
FRP, Paint, Mat, Wood
H16xW20xD12
2013

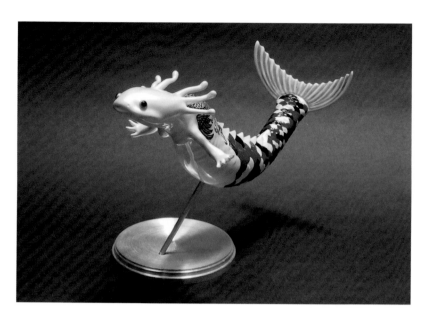

salamander[MARMAID]
FRP, Paint, Alminum
H15.5x W22xD10
2013

salamander[ANGEL]
FRP, Paint, Stainlesssteel
H25xW20xD12
2013

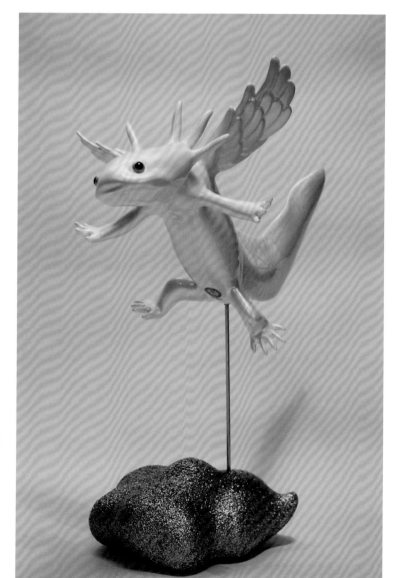

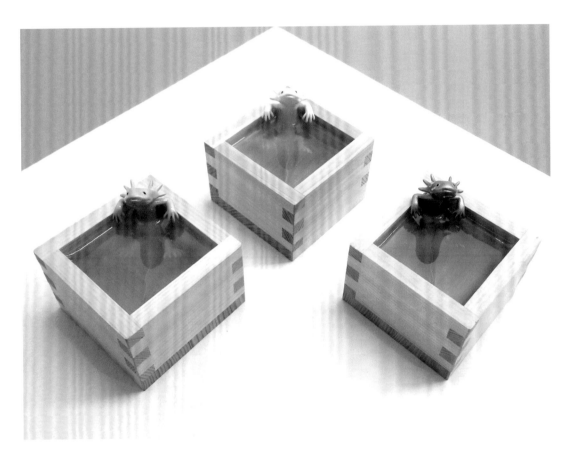

salamander[BATH]
FRP, Trans parent plastic,
Squares, Paint
H70xW85xD85
2014

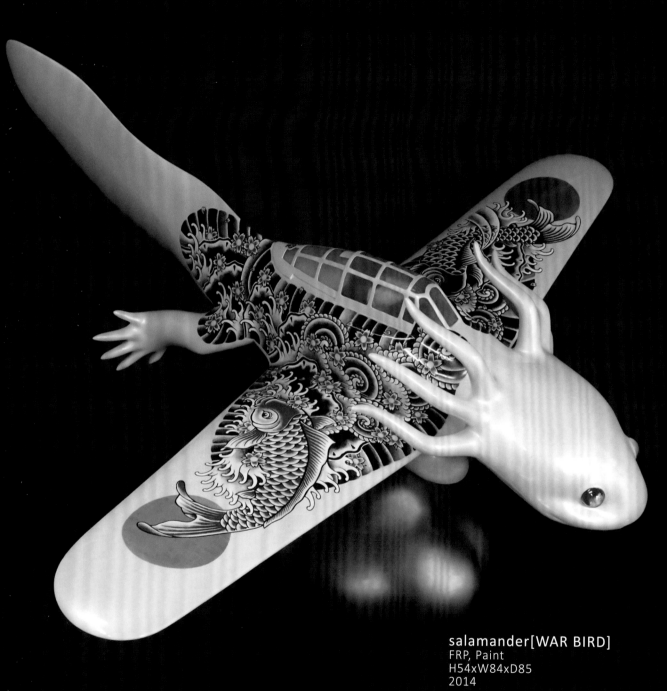

salamander[WAR BIRD]
FRP, Paint
H54xW84xD85
2014

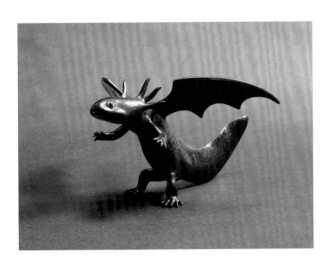

salamander[FIGHTER]
FRP, Paint
H12xW18xD20
2014

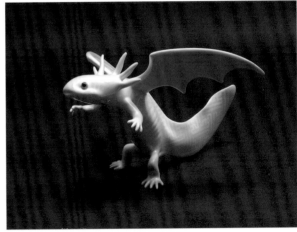

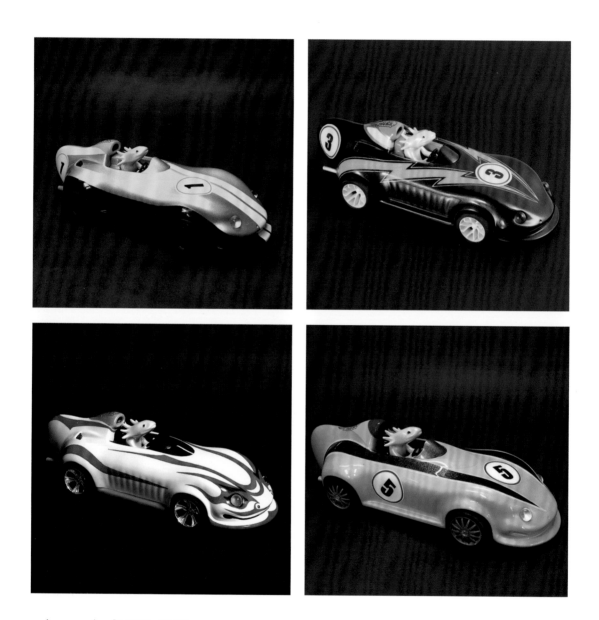

salamander[MINI-CAR]
FRP, Paint, Toy'stire
H7xW20xD8
2015〜

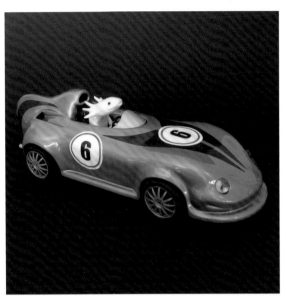 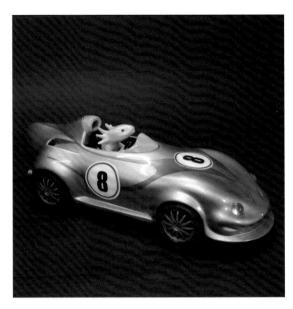

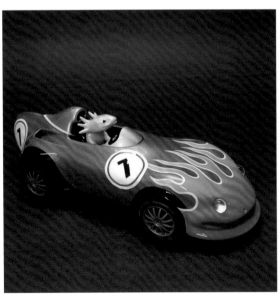 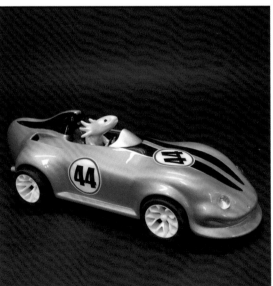

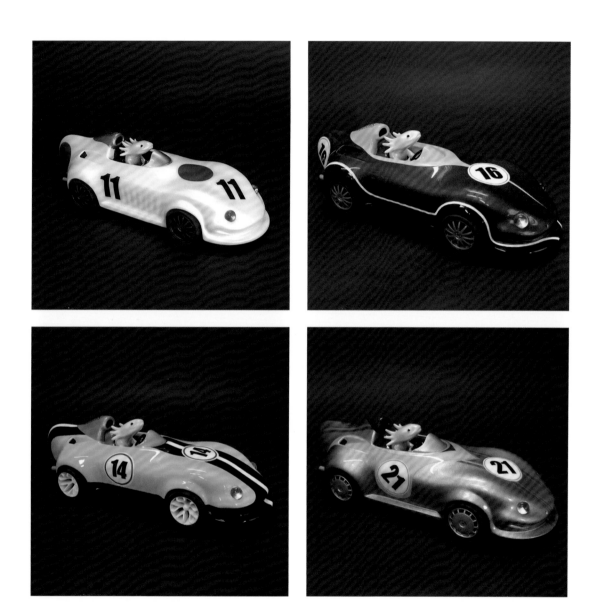

salamander[MINI-CAR]
FRP, Paint, Toy' stire
H7xW20xD8
2015〜

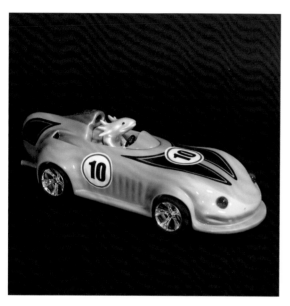

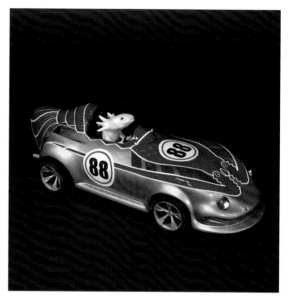

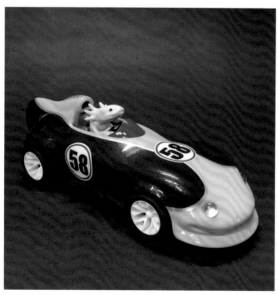

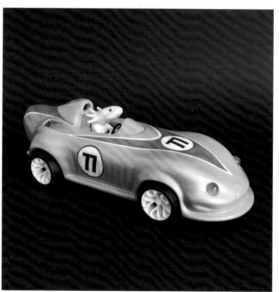

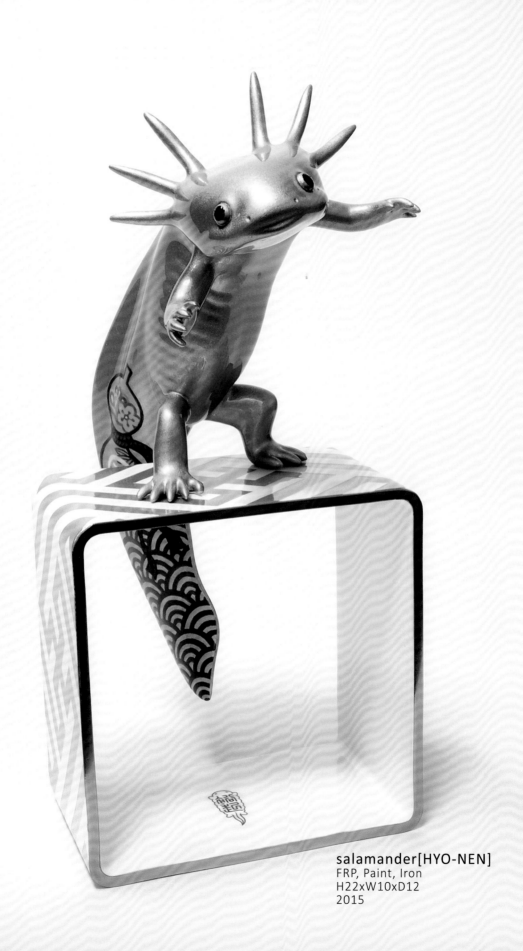

salamander[HYO-NEN]
FRP, Paint, Iron
H22xW10xD12
2015

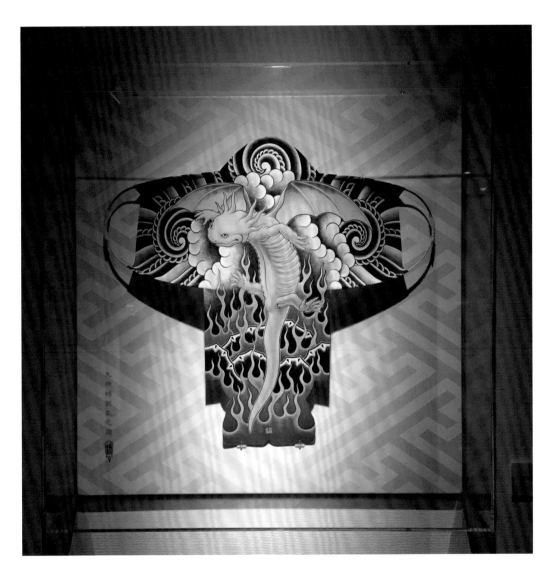

火蜥蜴誕生之図
Acylic on paper, wood
H68xW68xD10cm
2016

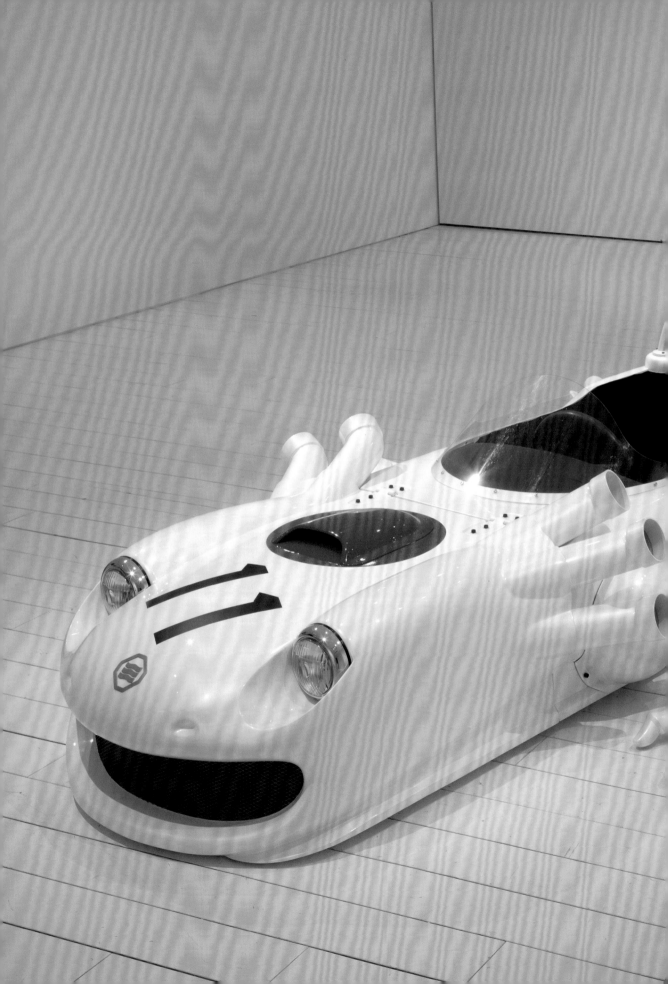

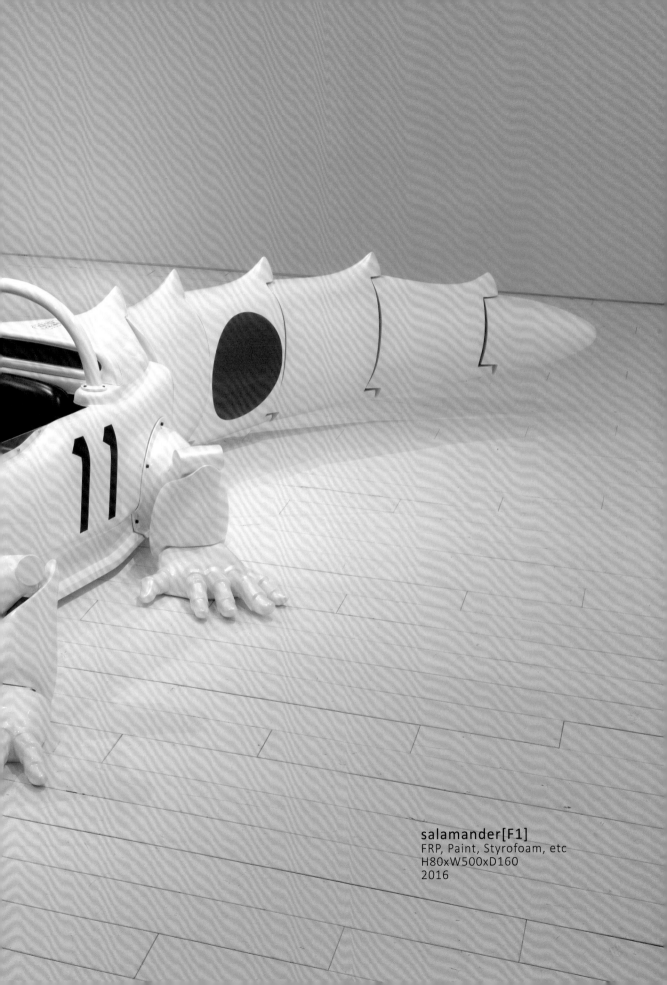

salamander[F1]
FRP, Paint, Styrofoam, etc
H80xW500xD160
2016

poison-dart frog[LANDMINE]
FRP, Paint, Stainless steel
H8xW8xD8
2017

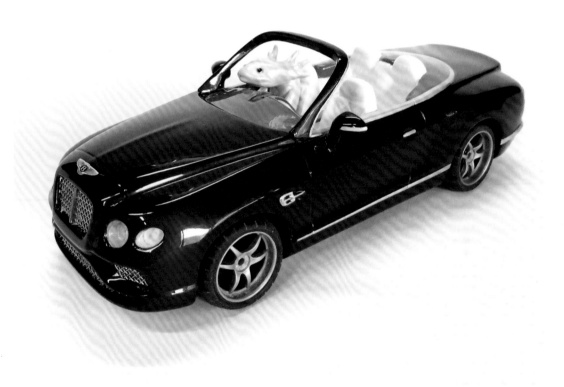

salamander[MINI-CAR]
FRP, Paint, Toy' stire
H8xW22xD8
2017

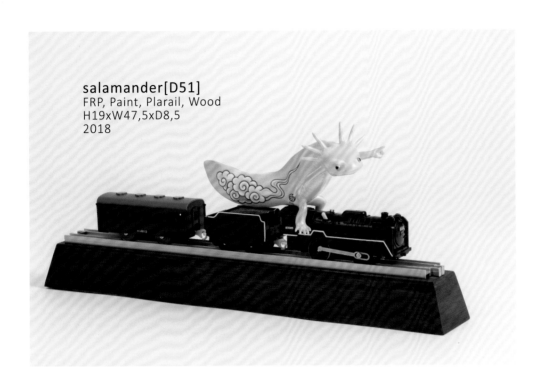

salamander[D51]
FRP, Paint, Plarail, Wood
H19xW47,5xD8,5
2018

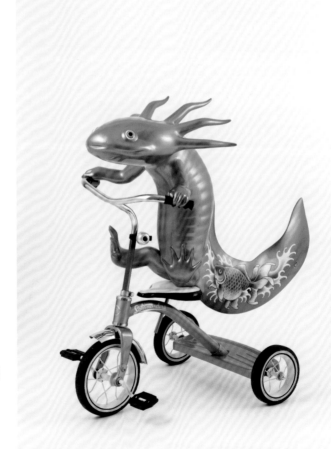

salamander[TRICYCLE]
FRP, Paint, Tricycle
H90xW93xD58
2018

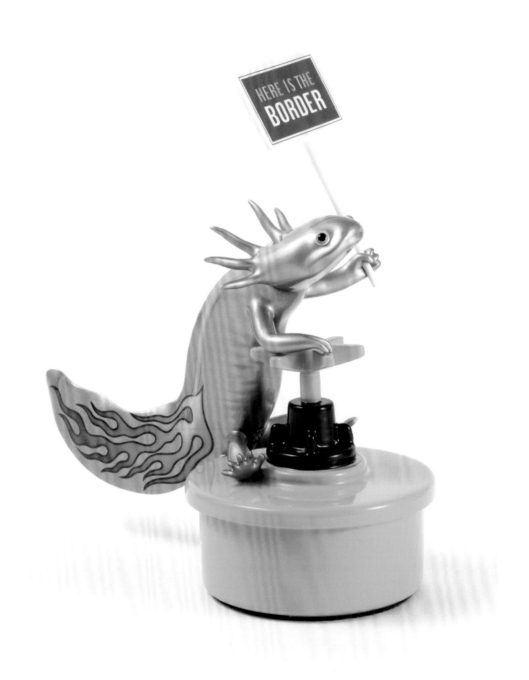

salamander[BORDER]
FRP, Paint, Stainlesssteel
H20xW13xD20,5
2018

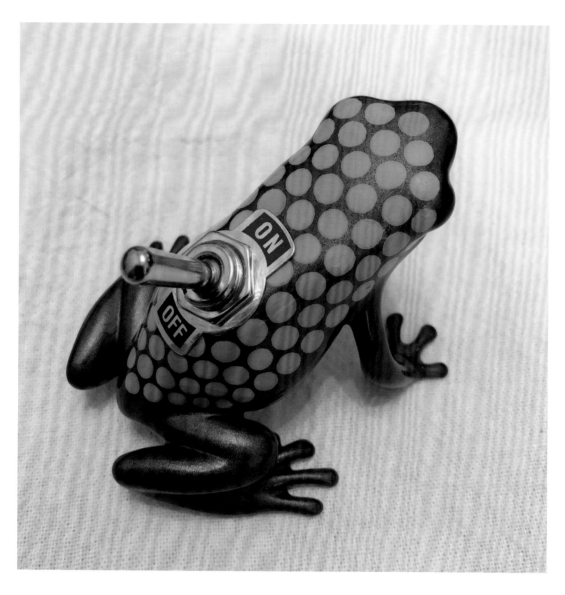

poison-dart frog[SWITCH]
FRP, Paint, Toggle switch
H8xW8xD8
2018

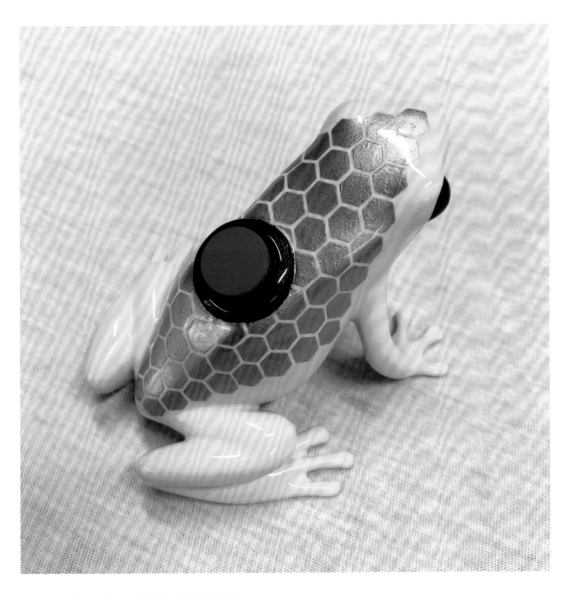

poison-dart frog[RED BUTTON]
FRP, Paint, Push switch
H7x W8x D8
2018

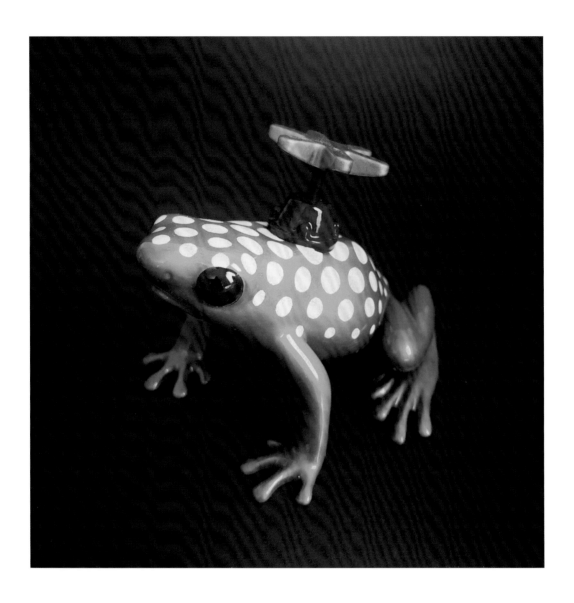

poison-dart frog[LANDMINE]
FRP, Paint, Stainless steel
H8xW8xD8
2018

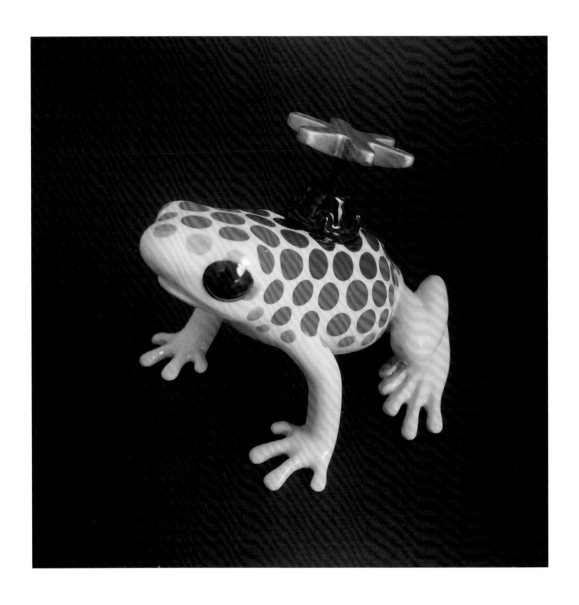

poison-dart frog[LANDMINE]
FRP, Paint, Stainless steel
H8xW8xD8
2018

鯢百態

以兩棲類的鯢為文化載體，
藝術家娓娓道來日本文化的瑰麗進化

One hundred modes of Salamander

Taking the amphibious salamander as a cultural carrier.
The artist tells the magnificent evolution of Japanese culture.

鯢百態

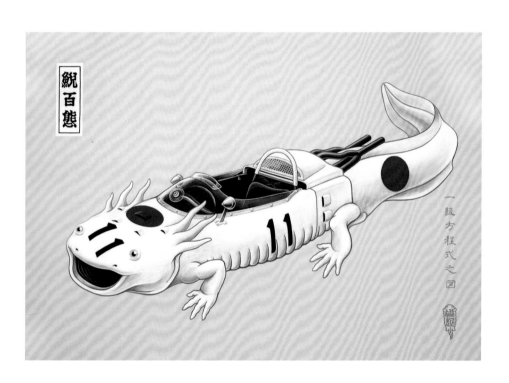

鯢百態[一級方程式之図]
Acrylic on paper
H36,4xW51,5(B3)
2015

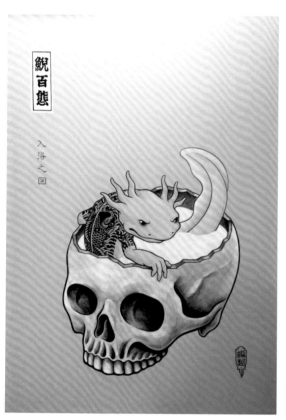

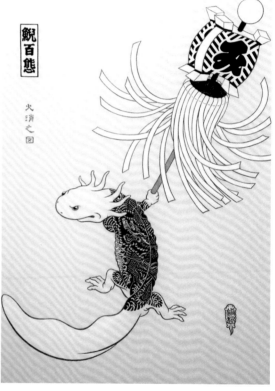

鯢百態[入浴之図]
Acrylic on paper
H51,5xW36,4(B3)
2015

鯢百態[火消之図]
Acrylic on paper
H51,5xW36,4(B3)
2015

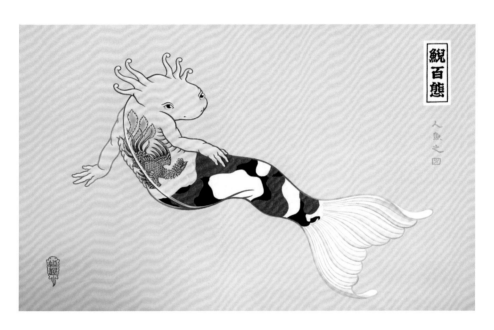

鯢百態[人魚之図]
Acrylic on paper
H36,4xW51,5(B3)
2015

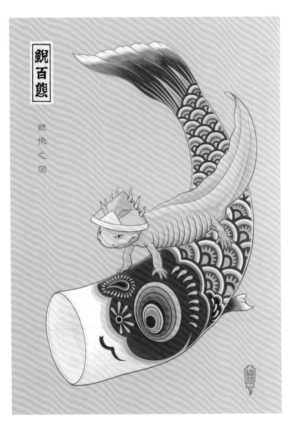

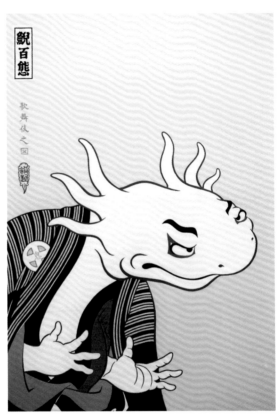

鯢百態 [鯉幟之図]
Acrylic on paper
H51,5xW36,4(B3)
2015

鯢百態 [歌舞伎之図]
Acrylic on paper
H51,5xW36,4(B3)
2015

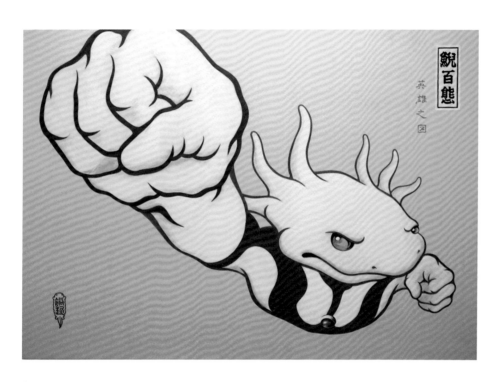

鯢百態[英雄之図]
Acrylic on paper
H36,4xW51,5(B3)
2015

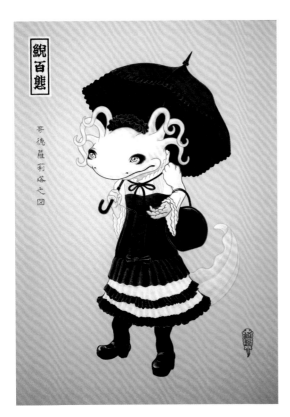

鯢百態[哥德蘿莉塔之図]
Acrylic on paper
H51,5xW36,4(B3)
2016

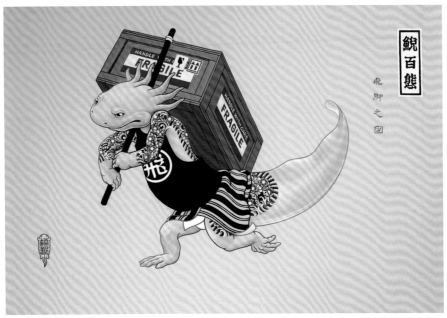

鯢百態[飛脚之図]
Acrylic on paper
H36,4xW51,5(B3)
2016

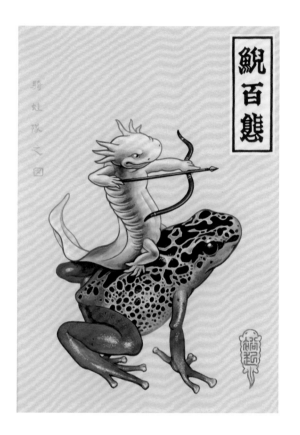

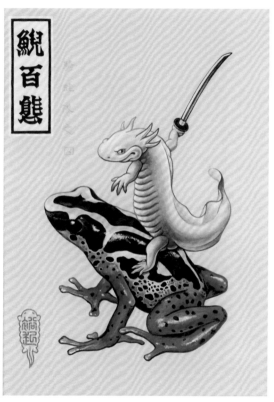

鯢百態[騎蛙隊之図]
Acrylic on paper
H25,7xW18,2(B5)
2017

鯢百態[騎蛙隊之図]
Acrylic on paper
H25,7xW18,2(B5)
2017

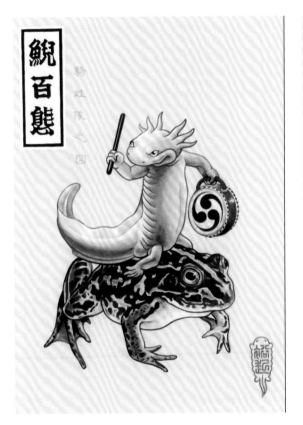

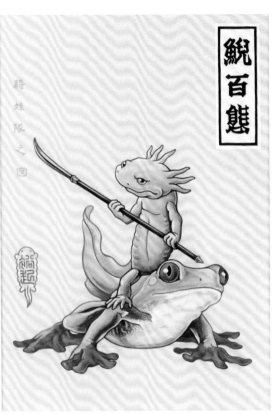

鯢百態[騎蛙隊之図]
Acrylic on paper
H25,7xW18,2(B5)
2017

鯢百態[騎蛙隊之図]
Acrylic on paper
H25,7xW18,2(B5)
2018

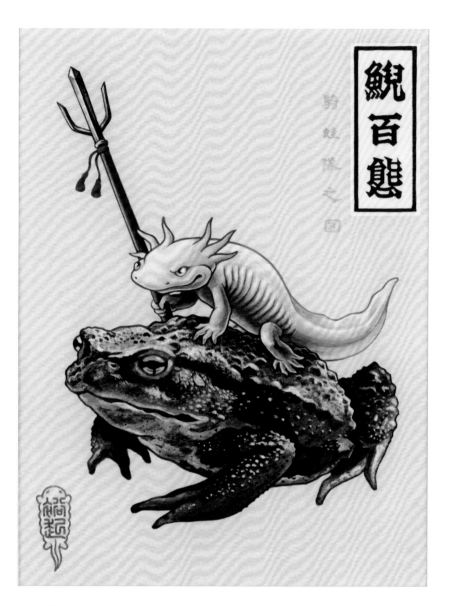

鯢百態 [騎蛙隊之図]
Acrylic on paper
H25,7xW18,2(B5)
2017

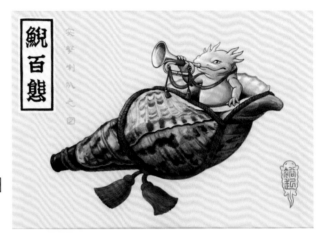

鯢百態[突擊喇叭之図]
Acrylic on paper
H25,7xW18,2(B5)
2017

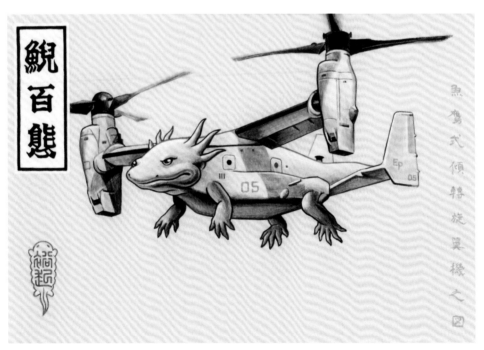

鯢百態[魚鷹式傾轉旋翼機之図]
Acrylic on paper
H25,7xW18,2(B5)
2017

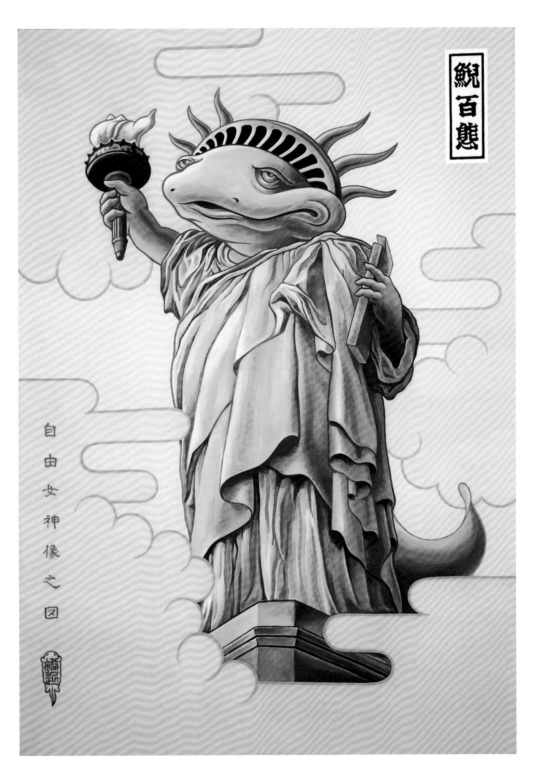

鯢百態[自由女神像之図]
Acrylic on paper
H51,5xW36,4(B3)
2017

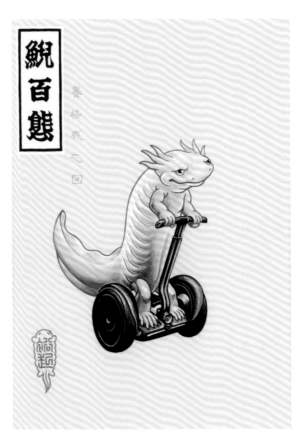

鯢百態[賽格威之図]
Acrylic on paper
H25,7xW18,2(B5)
2017

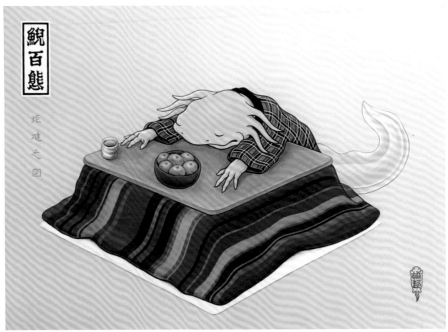

鯢百態[炬燵之図]
Acrylic on paper
H36,4xW51,5(B3)
2018

作品索引 List of works

風格百錦

鯢百態